The Photographer's Guide to
BLACK AND WHITE

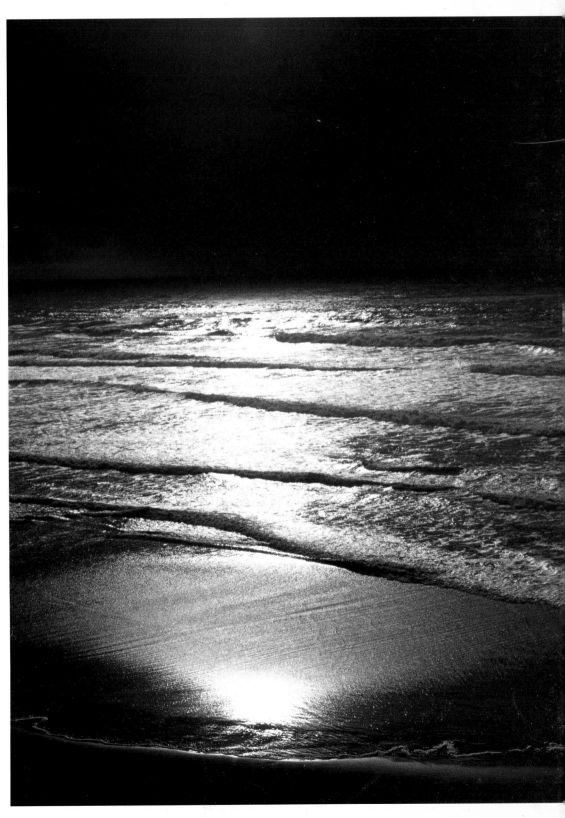

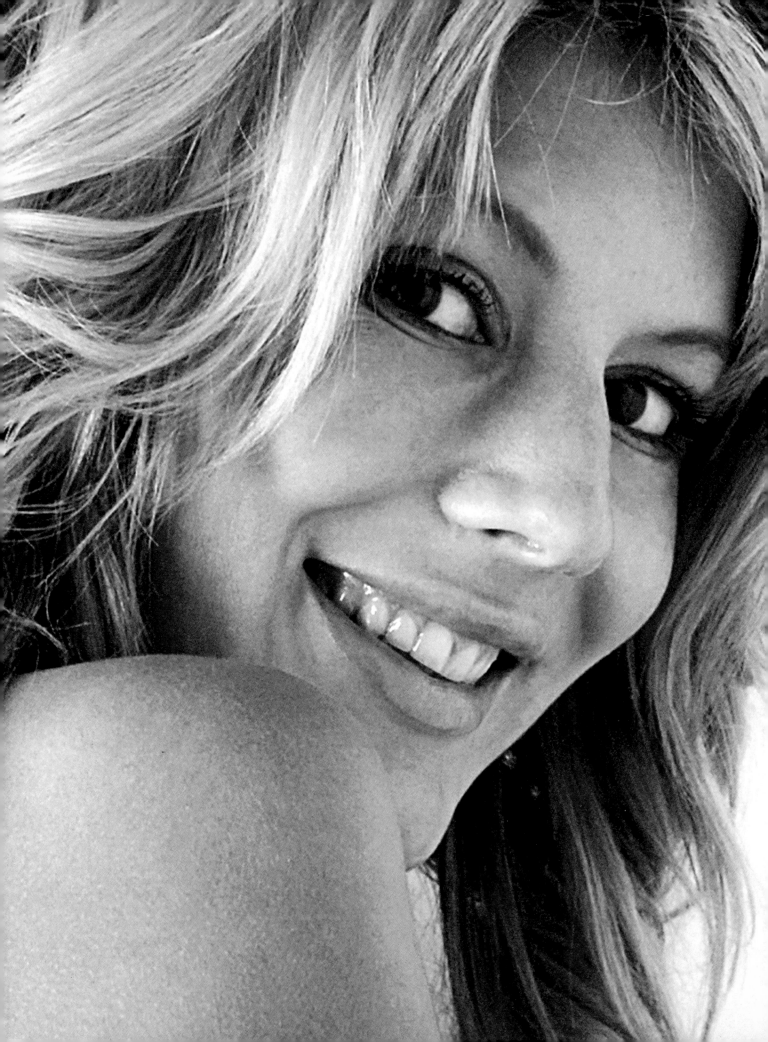

The Photographer's Guide to

BLACK AND
WHITE

John Freeman

COLLINS & BROWN

Dear Carole "2006"

Now You Have
the Book......
It's Time
To Take
some Photos!
Hope
you
Enjoy!
love
Leslie

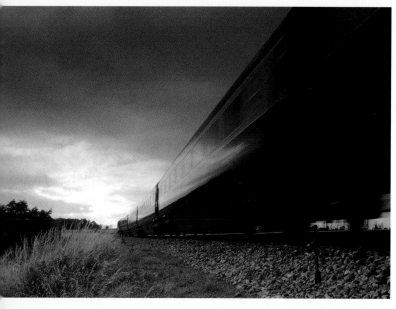

For my daughter, Katie

First published in Great Britain in 2006 by
Collins & Brown
151 Freston Road
London
W10 6TH

An imprint of Anova Books Company Ltd

Distributed in the United States and Canada by
Sterling Publishing Co, 387 Park Avenue South, New York,
NY 10016, USA.

Commissioning Editor: Chris Stone
Copy Editor: Cathy Joseph
Design: Philip Clucas MSIAD
Digitial Systems Operator: Alex Dow
Jacket Design: Jason Godfrey

ISBN [10 DIGIT] 1 84340 178 9
[13 DIGIT] 9 781843 401780

A CIP catalogue record for this book is available from the
British Library.

10 9 8 7 6 5 4 3 2 1

Reproduction by Classicscan
Printed and bound by Kyodo, Singapore

This book can be ordered direct from the publisher.
Contact the marketing department, but try your bookshop first.

www.johnfreeman-photographer.com

Contents

Introduction

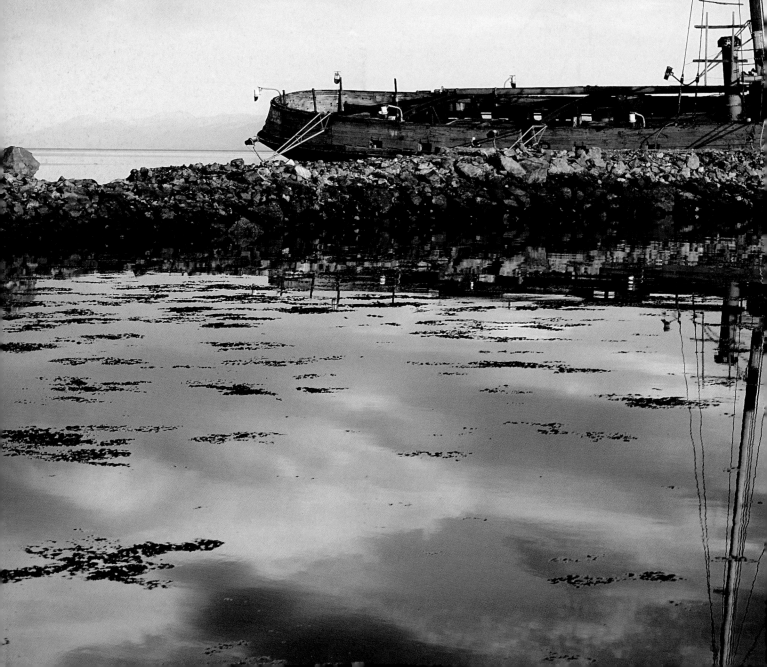

Over the last few years there has been a revival of interest in black and white photography, so much so that, for some people, it has almost become a fashion statement. Walk into any of the modern furniture stores and look at the artwork they have for sale. Much of it will be black and white photography. Some of the prints might be from old masters such as Ansel Adams and Cecil Beaton, or more modern exponents like Herb Ritts and Sebastiao Salgado. Nor is the medium only popular in the home. Restaurants, hotels and offices also display black and white imagery, often because it appears to be cool to do so - much more than colour photography.

This is all a far cry from the beginning of photography, when the goal was to create an image with acceptable colours. Even in the very early days, when sepia toning a print was done to give it permanence, people started to adopt it as a form of colour photography, rather than for its archival qualities. Towards the end of the twentieth century, it became quite difficult for amateur photographers to get black and white film processed and decent black and white prints made. Whereas colour photography could be churned out in a couple of hours, black and white film had to be sent away to be processed. However, there were professional labs who

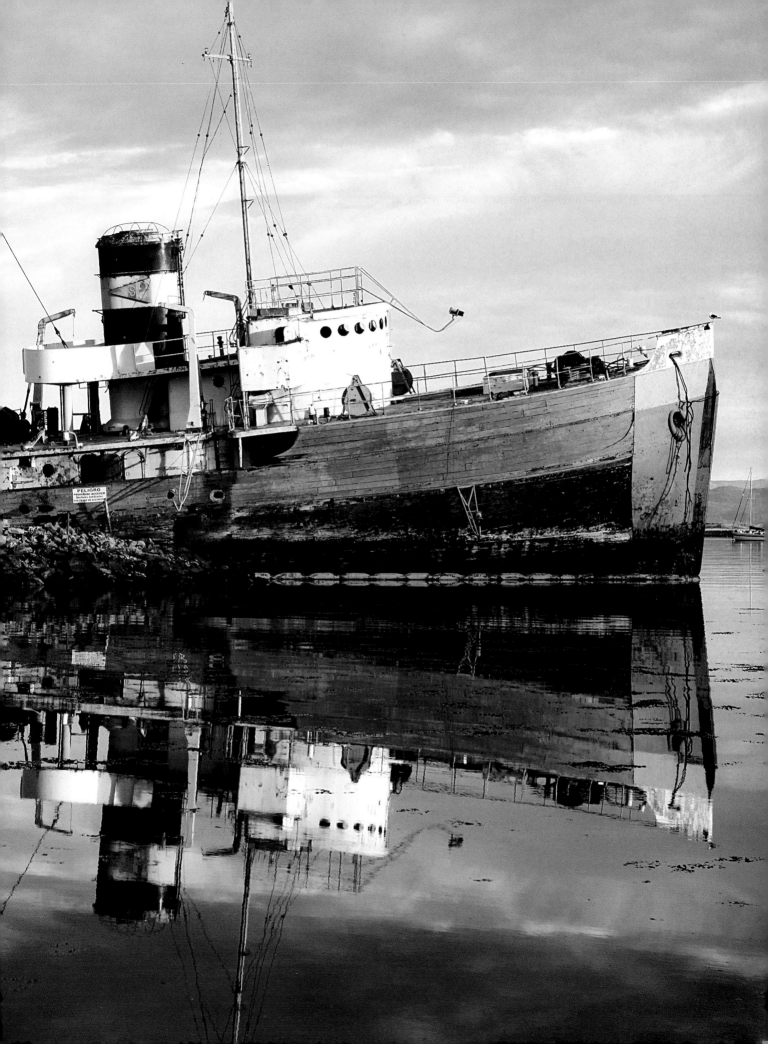

could offer a range of developers and papers and who would produce exhibition quality prints. Many of these now find themselves in demand, as digital imagery has forced many of the less specialist labs to close.

At the height of black and white film production, there were numerous monochrome films available, made by several different manufacturers. Besides Kodak and Ilford, there was Agfa and, to a lesser extent, Fuji. Many of these films were for specialist markets and ranged from slow emulsions like Kodak's Technical Pan 25, through to high speed recording film, created for low light surveillance photography.

For many, the demise of such film is almost akin to a death in the family. But photography has always been a medium of innovation and in the digital age there are just as many, if not more, ways of producing imagery that is just as good, if not better, than the "old" methods. When people talk about digital being "all manipulation", my answer is: "nothing has changed then." As mentioned earlier, doing something as simple as sepia toning is a form of manipulation. Dodging and burning to produce a great bromide print is manipulation. Using chemicals such as potassium ferricyanide or selenium toner is manipulation. Today the use of such chemistry can be replicated on the computer with far less harm to either the environment or yourself.

As digital becomes the norm and time passes, photographers will probably gather together and reminisce about early digital processes. The shots I took for the infrared section, (pages 130–133) were taken on an older digital camera that was not fitted with a particularly good hot mirror filter. My new state-of-the-art camera is far more sophisticated and it is impossible to do infrared photography unless I get the hot mirror filter removed. This would obviously be uneconomical, to say the least! So even in the brave new world of digital photography, there are already sought after pieces of equipment that are no longer being manufactured.

Whatever the medium you use for your photography, it could be said that, whereas a colour photograph records a scene, black and white photography interprets it. People have become more discerning in the way they see and read a picture. It is all too easy for any colour photograph, however good or bad, to appeal because, after all, that is the way we see our environment. Because black and white is an interpretation of a scene, rather than a straight record of what is there before the eye, there is a greater emphasis on texture, tone and composition, with no pretty colours to hide behind!

Seeing what will make a good black and white photograph means differentiating between contrast more than colour, which is something that comes with practice. Try this simple test next time your in a supermarket. Often you can buy a packet of three peppers, usually red, green and yellow. In colour, they are all quite distinguishable from one another. However, if I were to photograph them in black and white, it would only be the yellow one that would appear noticeably different because it would be so much lighter. The red and the green would look virtually the same tone of grey.

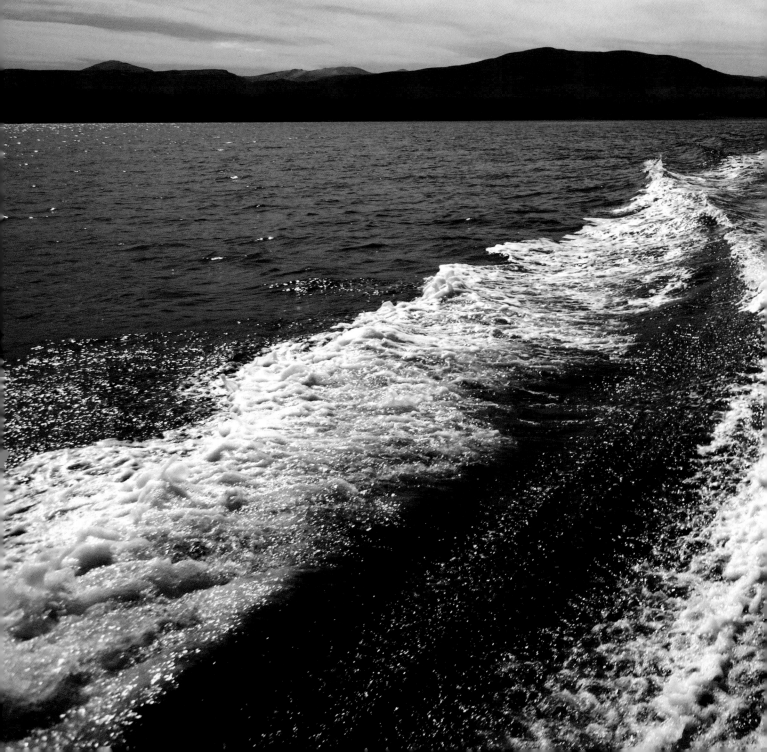

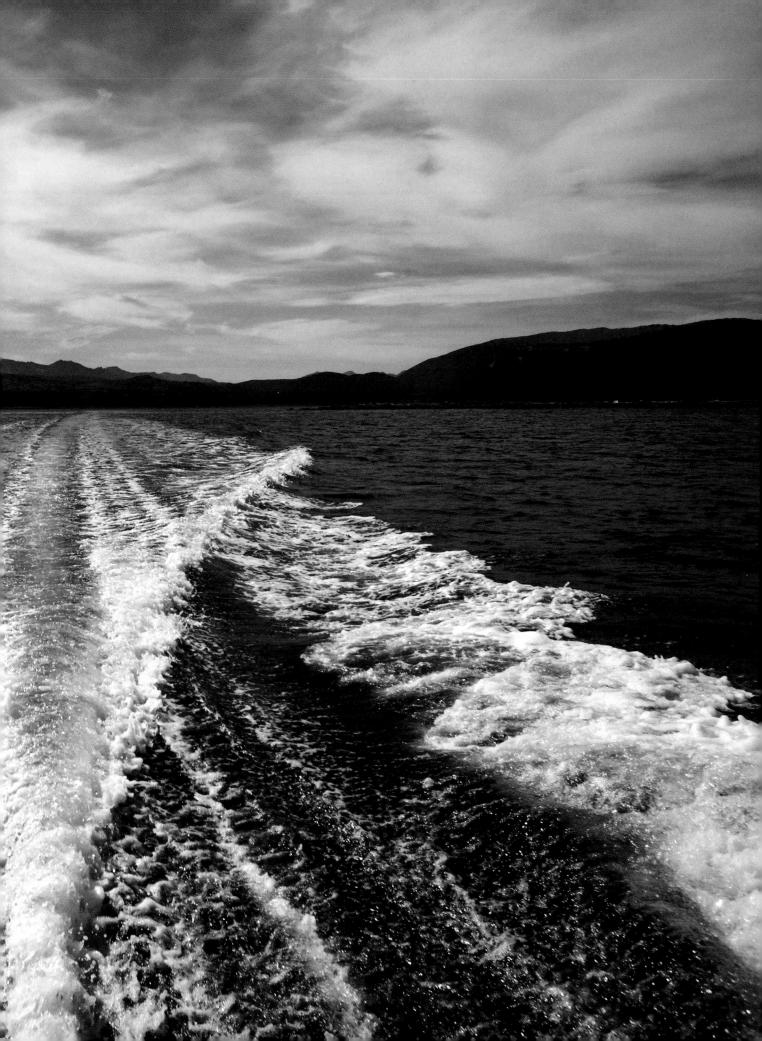

1 The Essentials

Basic Equipment

While there is no one piece of photographic equipment that is going to give you perfect black and white shots in every situation, there are certain key items of kit that will definitely assist you in your picture making. As with colour photography, some cameras might give spectacular results in certain situations, while, with others, the results might not be so eye catching. This could be due to the format. For example, a 5 x 4 camera might be great in a studio situation but unwieldy, to say the least, if you had to use it for sports photography.

The camera that has proved itself to be the most versatile is the single lens reflex (SLR). When you buy one of these, whether it is a film or digital version, you are really buying a body on which other elements can be attached and fitted. These could be lenses, filters, extension tubes and, in the case of medium format SLR's, different film backs or high-end digital backs. 35mm digital SLR's are growing in popularity and more models are becoming full-frame versions. Many of these have

the ability to shoot in black and white. The others will require the colour images to be downloaded into the computer and converted into black and white using a program such as PhotoShop.

The great thing about shooting digitally is being able to see the result instantly on the camera's LCD screen. This means that you can perfect the composition and viewpoint and examine the histogram to ascertain the correct exposure; so that every shot should be the way you envisaged it. As opposed to film cameras, which require you to carry around a lot of bulky film and maybe Polaroid as well, digital cameras are very compact, as you only have to carry memory cards in addition to the kit itself.

If you do decide to invest in an SLR camera, you will need to decide which lenses are going to be the most useful. A good starting point will be to purchase three different zoom lenses, which should cover you for most subjects. I usually suggest a 16–35mm, 24–70mm and a 70–200mm. The better the quality of the lens, the better your results will be. It is always

1. Lenses: 16-35mm; 24-70mm; 70-200mm.
2. Medium-format SLR camera
3. Compact flash cards
4. Digital SLR camera

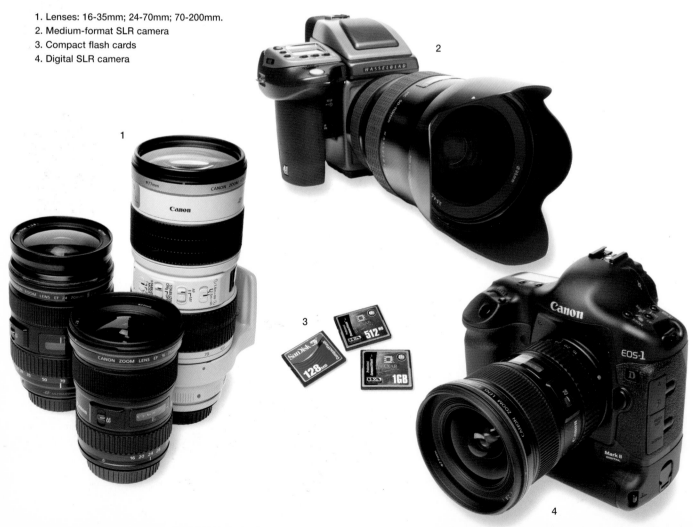

advisable to buy the fastest lenses you can afford. The speed refers to the maximum aperture of the lens, so f/2.8 is faster than f3.5 or f5.6. Another point to consider is that some lenses, such as a 70–200mm, might vary from f3.5 when the focal length is set to 70mm, to only f5.6 when adjusted to 200mm. Although a lens with a consistent aperture of, say, f2.8 throughout its range, will be much more expensive, the results will be impressive.

A useful addition is a 2x extender. With this, your 200mm lens will become a 400mm, but will be a lot lighter to carry. The only drawback is that you will lose two stops, so that an f2.8 lens will in effect become f5.6. A set of extension tubes, which will enable you to get in really close to your subject, is another accessory that should not be overlooked.

5. Slip in and screw on filters
6. Extension tubes
7. Exposure meter
8. Backpack
9. Tripod
10. Pan-tilt head

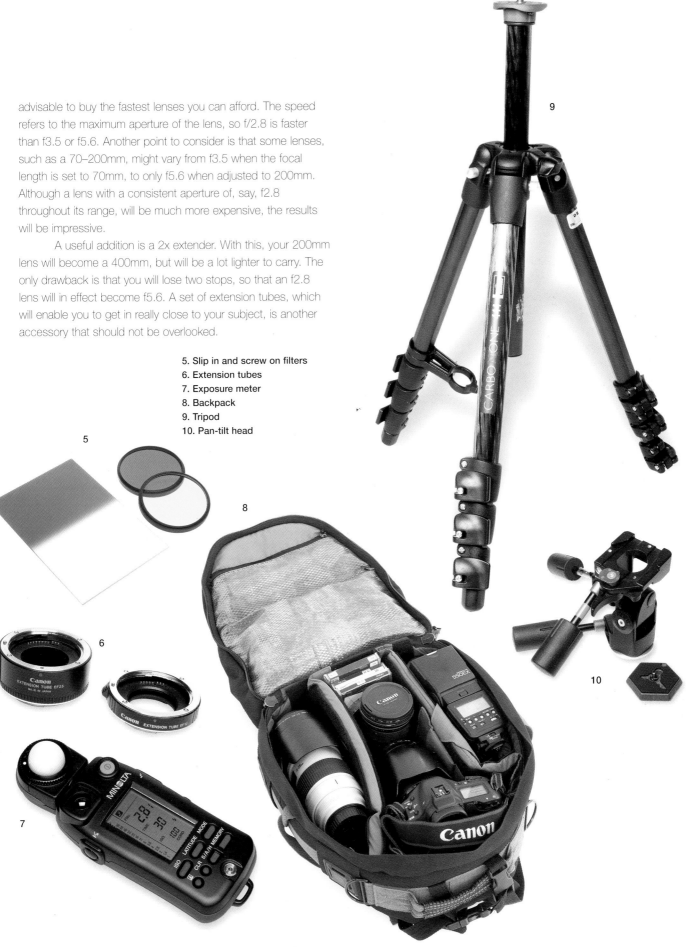

Basic Equipment Continued

Besides the camera and its lenses, there are other key pieces of kit that you should not be without. One of these is a good light meter. This is essential for getting accurate exposures as it will allow you to take incident light readings. This is where you read the light falling on your subject as opposed to the light reflected from it, which is how built-in meters take their readings.

Another accessory to keep with you, whether you are shooting digitally or on film, is a set of filters. These should include a couple of graduated neutral density filters of different strengths, to help retain detail in skies while keeping the foreground correctly exposed. Another filter that will enhance both the sky and water in your landscape photography is the polariser. The circular type will be essential if you use ultra wide-angle lenses a lot. Yellow and red filters are also worth considering for black and white photography. The yellow filter will bring out the clarity of clouds against a blue sky, while a red filter will darken a blue sky to give a dramatic, almost night-time appearance.

Two final items that will form a versatile, basic kit are a dedicated flashgun, which will prove useful and is far more effective than the built-in variety, and a really good tripod. The idea of trekking through the desert or forest with such a bulky item might not appeal, but it is probably the most important piece of equipment after the camera. With it, you will be able to take rock steady shots at very slow shutter speeds, compose accurate horizontal images for building panoramas and position graduated filters precisely – to name just a few of its uses.

1. **Dedicated flash-gun**
2. **Electronic flash power-pack**
3. **Reflectors**
4. **Ring flash**
5. **Mono-bloc**
6. **Softbox**

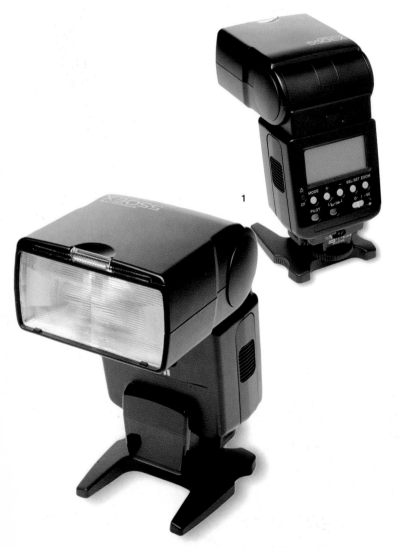

1

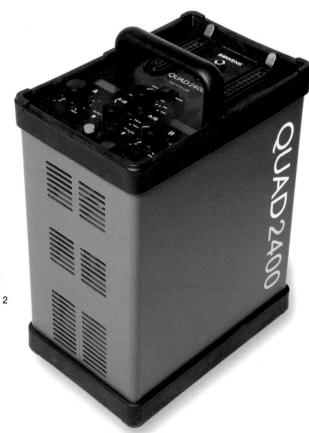

2

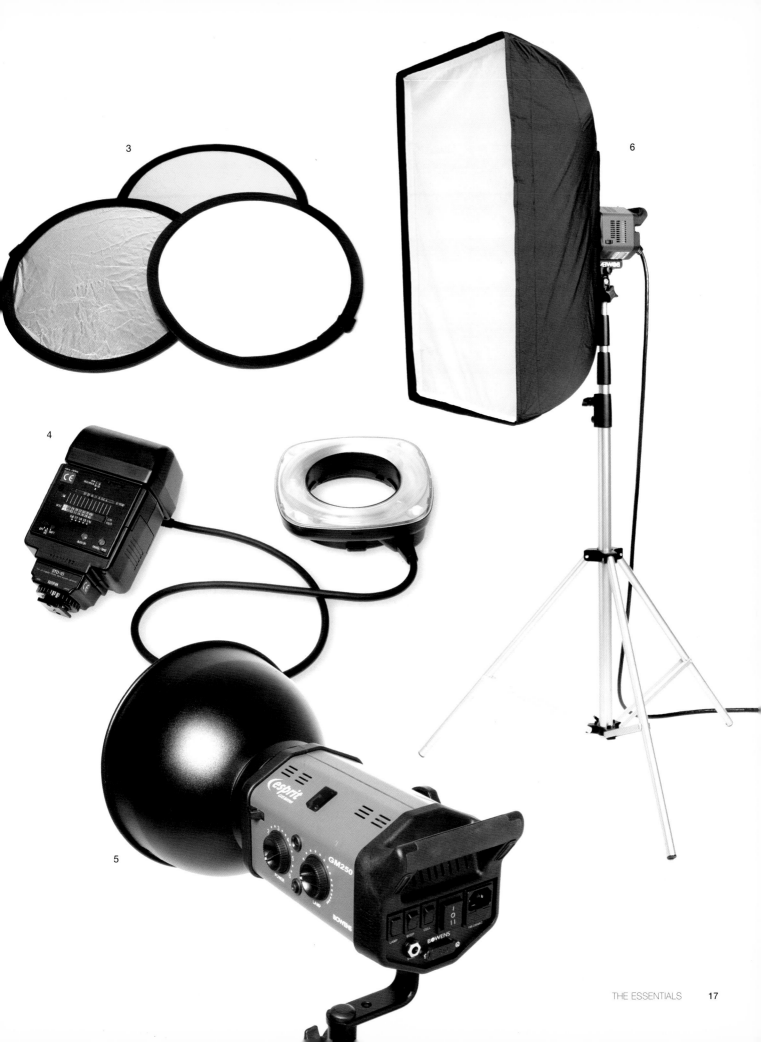

3

6

4

5

Normal Lenses

The standard, or normal, focal length lens is, on a 35mm camera, between 45mm and 55mm. This provides roughly the same angle of view as that of the human eye. Any lens with a lower focal length than this, for example 28mm, will give a wider angle of view and any lens with a higher focal length, for example 200mm, will give a narrower angle of view.

Because many cameras these days are sold complete with a zoom lens that will have a range somewhere between 28mm and 100mm, the standard lens is often forgotten. However, because of its similarities to our own field of vision, a standard lens can be a good choice when it comes to framing your picture. Unlike wide-angle lenses where it is all to easy to include a lot of unwanted detail, or telephoto lenses which can crop too much out, this lens gives the same view that made the shot appealing in the first place. It also has a reasonable depth of field so, by careful choice of aperture, you can control the area of sharpness to suit your subject.

Apart from the quality of the components, and therefore the price, it might appear that there is little to choose between one manufacturer's 50mm lens and another's. All lenses are made up of glasses, known as elements. This means that if you take a cross section of the standard lens, for example, you will see various pieces of concave and convex glass divided into a series of groups. A lens may have six to eight groups in total and this configuration is crucial, not only to the standard lens, but to all lenses, whatever their focal length. The difference that one make of lens has over another may affect the contrast and sharpness of your pictures. This is especially apparent with black and white photography and often a professional photographer will favour one brand over another because of its particular characteristics.

A lens with a maximum wide aperture of f2 will be faster than one with a maximum wide aperture of f3.5 or f4. These faster lenses, will cost considerably more, but their overall performance outstrips slower counterparts.

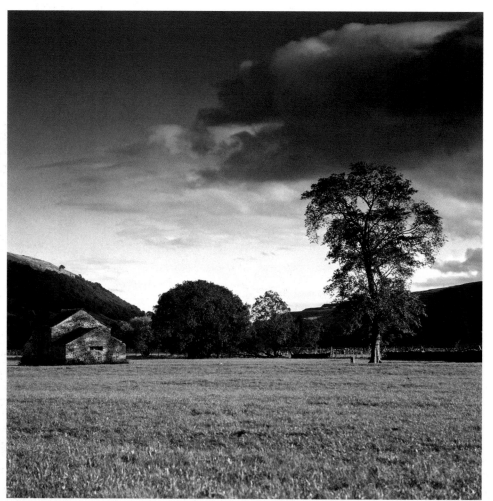

Left: Normal or standard lenses have roughly the same angle of view as the human eye, and therefore can record the image with little or no distortion, or foreshortening of the subject. This could happen if we used a wide-angle or telephoto lens.

Opposite: The normal lens lets you work at a comfortable distance from your subject. This is important in portrait photography, as it allows you to have a rapport with your subject without crowding or intimidating them.

Below: Normal lenses vary in focal length depending on the format that you are using. For instance, the normal lens for 35mm is 50–55mm, whereas for 6 x 6 it is 80mm.

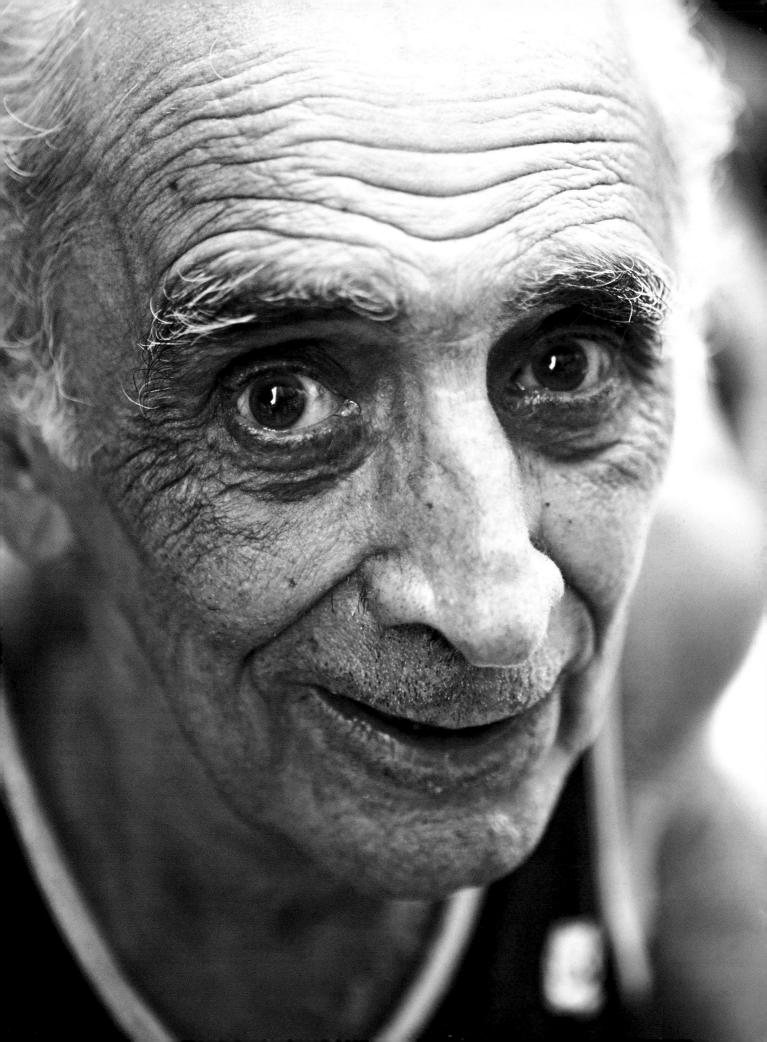

Wide-Angle Lenses

Wide-angle lenses have a field of view that can vary from the extreme 180° for a fish-eye lens, to 54° for a 35mm lens. There is no more advantage to using wide-angles for black and white photography than there is when shooting in colour. The most important aspect of any lens is that you chose the one most suited to the subject and the effect you want to achieve.

The first thing you notice when using wide-angle lenses is the sheer amount of subject matter that can be included in your shot. Because of this, viewpoint and framing are crucial to avoid filling the photograph with a lot of unwanted detail. Wide-angle lenses also have a greater depth of field than do standard or telephoto lenses, so more of the picture will be sharp, even at wide apertures. If these aspects are not controlled, the picture could end up being so busy that it will be difficult for the viewer to focus on the main subject.

Fish-eye lenses have the greatest angle of view but probably the fewest applications. They have extreme depth of field, which means that you can use them at their widest aperture and still get virtually everything in focus. After the novelty value has been exhausted, fish-eyes are best suited to specialist applications such as architecture.

Far more useful on a day to day basis are wide-angles that range between 16mm and 35mm. If well made, they will give very little distortion and are useful in a variety of applications, from landscapes to architectural photography. You will be able to include detail close to the lens while also keeping the background sharp. With thoughtful composition, such depth of field can be used to good effect as you can make the foreground detail look larger and more dominant than it is.

Care needs to be taken when shooting people with wide-angles, as features can appear distorted, especially if they are close to the lens. The effect can be unflattering, with the subject's nose looking extremely large or, if your viewpoint is quite high, their legs appearing stunted. Shoot from a low angle, however, and legs can seem longer than they actually are.

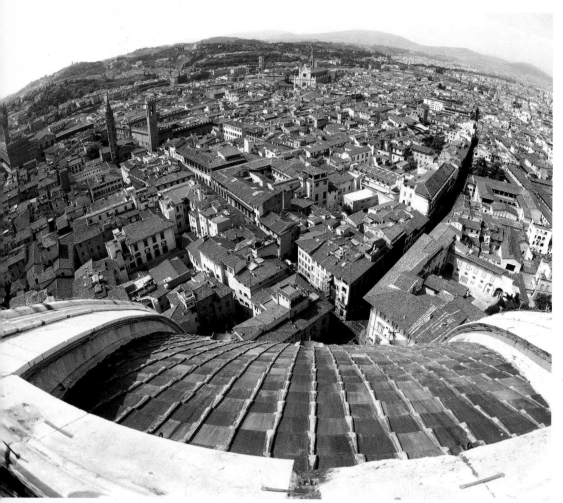

Left: The widest angle lens that you can get is the fish-eye, which has an angle of view of 180°. This lens has limited uses but, in certain situations, it can be very effective and give results that are unobtainable with any other lens.

Opposite: The most popular wide-angle lenses have a focal length somewhere in the region of 28 to 35mm. In this shot I used a 28mm and its increased depth of field gives good overall sharpness without the need to stop right down.

Below: Wide-angle lenses have a far greater depth of field than the human eye. For this reason they need to be used with extra care, as there is always the chance of including a lot of unwanted detail in your shot.

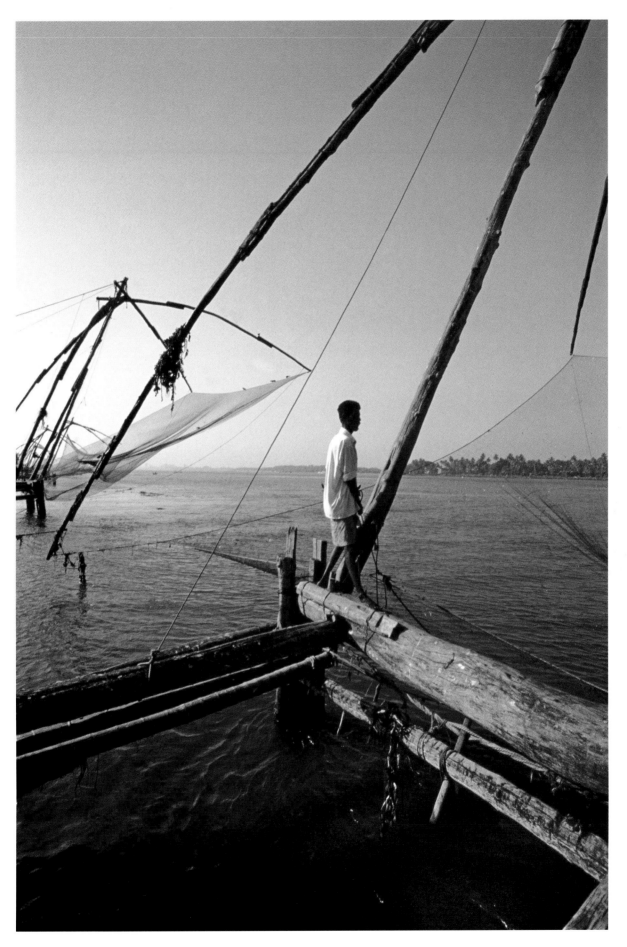

Telephoto Lenses

If wide-angle lenses have the ability to include an overwhelming amount of detail, telephoto lenses allow you to crop out nearly everything other than the main area of focus, which can often be an advantage. They fall into three distinct groups: short telephotos are 70mm to 120mm, medium telephotos 135mm to 300mm and lenses of 400mm upwards are known as ultra telephoto.

Telephoto lenses are sometimes referred to as zoom lenses, but this can be misleading. Although many of these lenses may "zoom" through a range of focal lengths, others have a fixed focal length and are known as prime lenses. Also, a zoom is not necessarily telephoto, it can just as easily be a wide-angle.

When buying digital cameras it is important to understand the difference between a digital zoom and an optical zoom. All a digital zoom does is enlarge the central portion of the frame making it appear that you have zoomed into it. However, it will result in a loss of quality because the final image has already been enlarged and then will be enlarged again when you come to make your print. You should therefore ignore this term and concentrate on choosing the right optical zoom for your needs.

Because telephoto lenses have limited depth of field, even when the lens is stopped down, they are ideal for subjects such as portraits. This is because you can put the background completely out of focus, creating an anonymous, mottled looking effect, which is a great aid to composition as it makes the subject really stand out. Another asset is the space these lenses allow you to create between yourself and your subject while still filling the frame. This means lights and reflectors can be placed close to your subject but still be cropped out of the frame.

Telephotos also have the effect of "compressing" the picture. This means that objects placed one behind the other appear to lose a sense of space between them, which results in a completely different, flatter, perspective than would be achieved with a standard or wide-angle. One of the drawbacks of telephoto lenses is their bulk, especially if they are 300mm or longer. They can be prone to camera shake so using a tripod or monopod, as well as a cable release, might be essential.

Left: Telephoto lenses are great for bringing distant subjects closer. In this shot, I used a 200mm lens together with a 2x converter. This gave an overall focal length of 400mm. If I had used a normal lens in this situation, I would have had to enlarge the image enormously to get this close. This would have resulted in an increase of grain, or noise, and loss of sharpness.

Opposite: Besides bringing distant objects closer, telephoto lenses also have less depth of field than normal or wide-angle lenses. This means that you can put the background out of focus, which gives added prominence to your main subject.

Below: In comparison to normal or wide-angle lenses, the telephoto has an extremely narrow field of view. On a 35mm camera, the angle of view is roughly 40° across the horizontal plane with a normal 50mm lens. However, when fitted with a 300mm lens, the angle of view is reduced to just 6.5° on the horizontal plane.

Understanding Depth of Field

While it is true that the aperture can control the amount of light passing through the lens, it can also control the area of sharp focus in front of the subject and behind it. This area is called the depth of field and it varies with different apertures and lenses. Two rules of thumb to remember are that a wide aperture will give less depth of field than a small one and a telephoto lens will have less depth of field than a wide-angle, even when both are set at the same aperture.

Imagine that you are shooting a subject that is three metres away from the camera. If the camera has a standard lens fitted and the maximum aperture of, say, f1.8 is set, very little in front of or behind the subject will be in focus. If you change the aperture to f8, the area of sharp focus will increase to include more of the foreground and a greater area of the background. If the lens is then stopped down to f22, an even greater area in front of the subject will be rendered sharply, as well as almost all of the background.

When using wide-angle lenses, depth of field is greater at all apertures than with a standard lens. This means that you can position your subject closer to the camera and still keep the background sharp. The reverse is true when using telephoto lenses where depth of field is less, even at small apertures. This can be used to creative effect, especially when taking portraits. Placing the subject in the foreground and using a wide aperture to blur the background will help to highlight your subject. A wide aperture also means that you can use faster shutter speeds, which will help to eliminate camera shake.

When you look through the viewfinder of a compact camera, or the LCD of a digital camera, you are seeing the picture at its widest aperture, whether the picture will be taken at that aperture or a smaller one. A major advantage of SLR cameras is that you can see the amount of the image that will actually be in focus by pushing a depth of field preview button. This is a great asset for spotting unwanted detail that will be apparent once the lens stops down as you press the shutter.

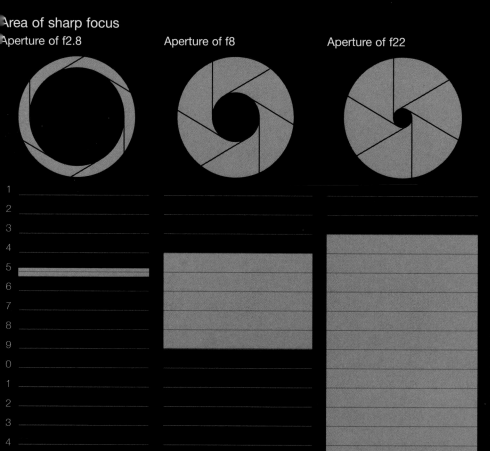

Area of sharp focus

Aperture of f2.8 Aperture of f8 Aperture of f22

1
2
3
4
5
6
7
8
9
0
1
2
3
4
5

This illustration shows the scale of sharp focus when the aperture is adjusted. When it is at its widest, very little of the picture is sharp, whereas the smaller the aperture, the greater the area of sharp focus. In the series of pictures opposite, the area of sharp focus can clearly be seen.
 (1) A 28mm wide angle lens was used with an aperture of f2.8. A great deal of the picture is in focus, with only a slight fall off in the very front and in the far distance. (2) When the lens is stopped down to f8, more of the picture is in focus, or sharper. (3) When the lens is stopped down to f22, all of the background and the foreground are in focus. (4) When the lens is changed to a 50mm standard lens and an aperture of f2.8 is used, far less of the picture is sharp than with the equivalent aperture used in picture 1. As the lens is progressively stopped down, first to f8 (5) and then to f22 (6), more of the picture becomes sharp but not as much as with the wide-angle lens. With a 100mm telephoto at f2.8, very little is sharp either side of the point of focus (7). At f8 (8) not much more is in focus and at f22 (9), only slightly more in front and

28mm f2.8

2 28mm f8

3 28mm f22

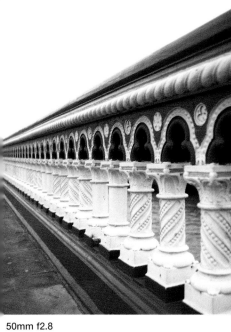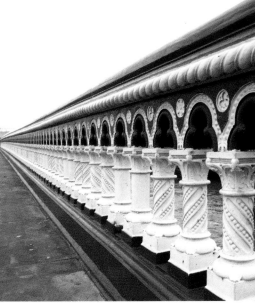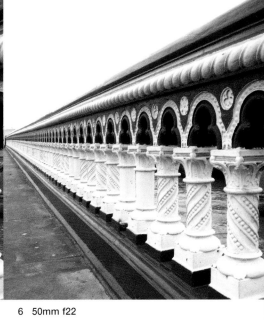

50mm f2.8

5 50mm f8

6 50mm f22

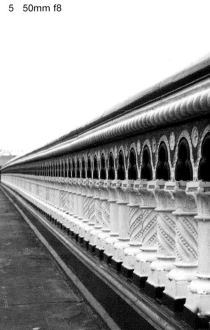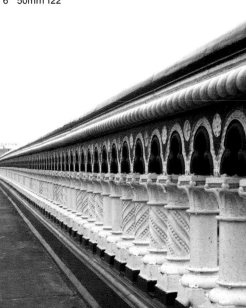

100mm f2.8

8 100mm f8

9 100mm f22

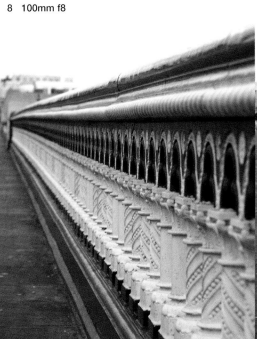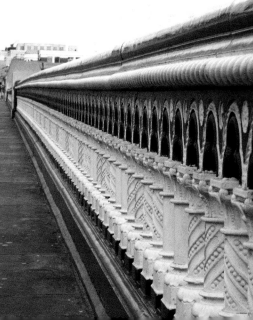

Understanding the Shutter

If the aperture controls the amount of light that passes through the lens, then the shutter determines for how long that amount of light takes to pass through it. On many cameras, especially the cheaper ones, the shutter speed is fixed. However, it is well worth choosing a camera that allows you to change the speed as it will greatly enhance your creative range.

On most cameras with adjustable shutters, the range will be from about 1 second to 1/1000th of a second, but this can extend from 30 seconds to 1/8000th of a second on sophisticated SLRs. Another setting on the shutter dial – the letter B - stands for bulb and is used for time exposures.

So what is the point of controlling the shutter speed? Imagine that you are at a fixed point beside a race-track, pointing the camera to the other side of it. You set the shutter to 1/60th of a second. A racing car comes along the track and, as soon as it is in front of the camera, you take your shot. The result will be a blurred car with all detail in its wheels and bodywork lost, while the background and foreground will be sharp. Now imagine doing exactly the same thing but with the shutter adjusted to 1/1000th second. As a result, everything in the picture is sharp, including the car. In other words, a fast shutter speed will freeze action whereas a slow one will not.

Sometimes a fast shutter speed creates the illusion that the car is not moving at all. A way around this is to use a slower shutter speed but "pan" the camera. This means following the car with the camera and releasing the shutter when it is in front of you. The effect of this is to blur the background while keeping the car sharp, giving the impression that it is travelling at high speed.

An adjustable shutter also gives you greater control over the aperture. Say the required exposure for a portrait is 1/125tth at f16. At this setting the background will stay sharp but, by choosing a faster shutter speed such as 1/1000th, you can select a wider aperture of f5.6. This will put the background out of focus and isolate your subject against it.

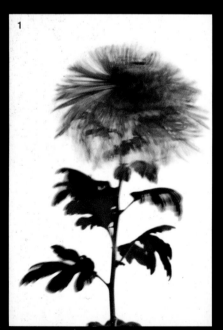
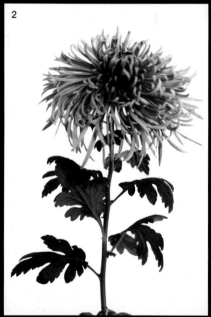
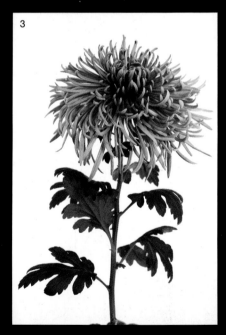

Using shutter speeds

These three pictures show the difference the choice of shutter speed make. In picture (1) a speed of 1/8th second was chosen and the flower is quite blurred, as it blew gently in the breeze. When a shutter speed of 1/30th second (2) was chosen, the flower is sharper but there is still a certain amount of movement. However, when the shutter speed was set at 1/125th second (3) the flower is quite sharp and the detail can be easily seen.

Opposite: Sometimes it is better to use a slow shutter speed to give a deliberate feeling of movement in your photographs. For this picture of a water fall, I used a shutter speed of 1/2 second, which has made the water quite blurred but gives a sense of movement. It was essential to have the camera mounted on a tripod to keep the other areas of the shot sharp. In cases like this, it is useful to have a neutral density filter handy in case you cannot stop down far enough for such a slow speed.

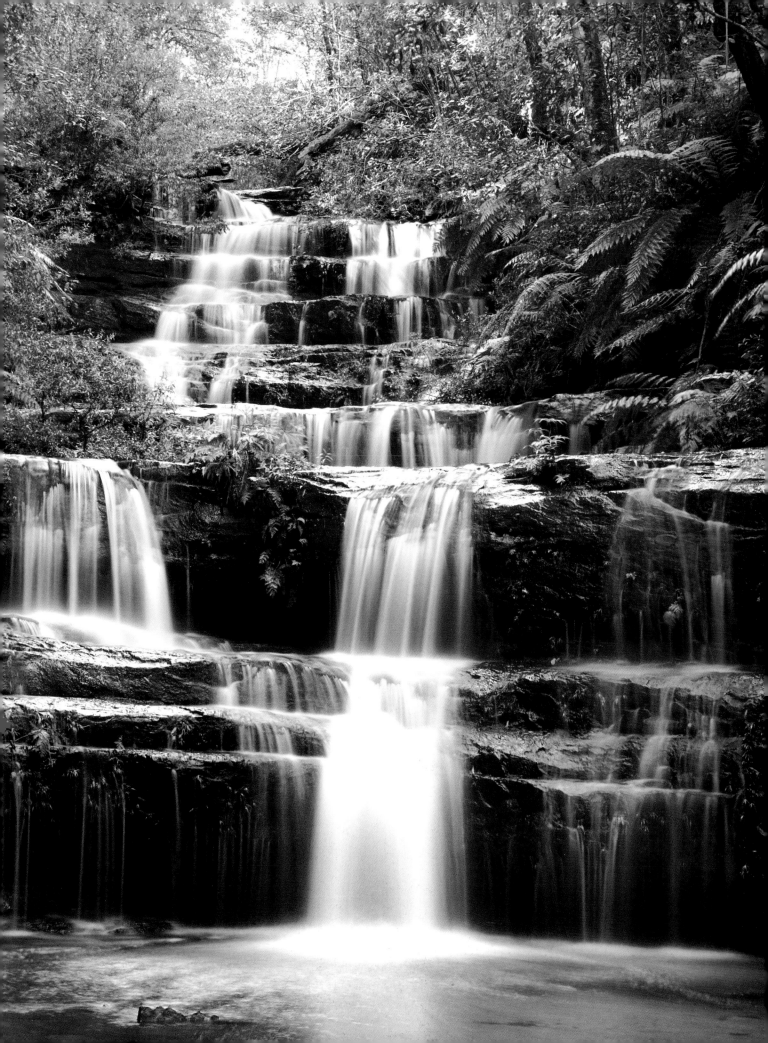

Understanding ISO

All film comes with a rating known as ISO, which stands for International Standards Organization. The ISO number on a film indicates the speed of the film. A low number, such as 25 ISO, means that the film has fine grain but will require brighter conditions or a greater length of exposure to record an image. A film with an ISO of 3200 will have courser, more evident grain but is capable of making an acceptable exposure in much lower light.

ISO is also applicable to digital photography and some cameras have the facility for the ISO speed to be selected. Instead of grain, the digital term for a similar effect is "noise". Setting the camera to 3200 ISO will mean that the image will have more noise and this could become unacceptable in the shadow areas. Setting the ISO to 50 will give less noise but, like film, will require a longer exposure.

All 35mm and APS films are DX coded. This means that the cassette has a bar code with all the information about that particular film, including its ISO rating. Once loaded, the camera can read this bar code and its built-in exposure metering system will adjust itself accordingly. On some cameras, it is possible to set the ISO manually and rate the film at a higher speed, for example 100 ISO at 400 ISO. If this is done, then an adjustment in development time will have to be made to compensate for the up-rating. This is known as "push processing". Obviously you have to shoot the entire film at that increased rating, as you cannot shoot a few frames at 100 ISO, some more at 400 ISO and the rest at 3200 ISO or the film would come out unevenly processed once developed. Digital cameras have an advantage here as you can adjust the ISO from frame to frame without having to worry about processing.

If a fast film has been used, the grain will become more pronounced as an image is enlarged. The effect is not necessarily something to be avoided and, in fact, many photographers deliberately aim for it to add to the mood of an image. On the computer, grain can be added in a controlled way, with a program such as Photoshop.

Fine Grain
When the chosen ISO is 100, photographs have a fine grain or noise. Even when the shot is enlarged (right) and the grain or noise increases, the sharpness begins to suffer but the result is still acceptable.

Coarse Grain
With the ISO at 1600, the grain or noise increases dramatically and the overall sharpness of the shot begins to diminish (right). When the shot is enlarged, this becomes even more apparent and, in certain situations, this would be unacceptable. But, as the shot on the opposite page shows, grain can add a dimension to the image that makes it more attractive.

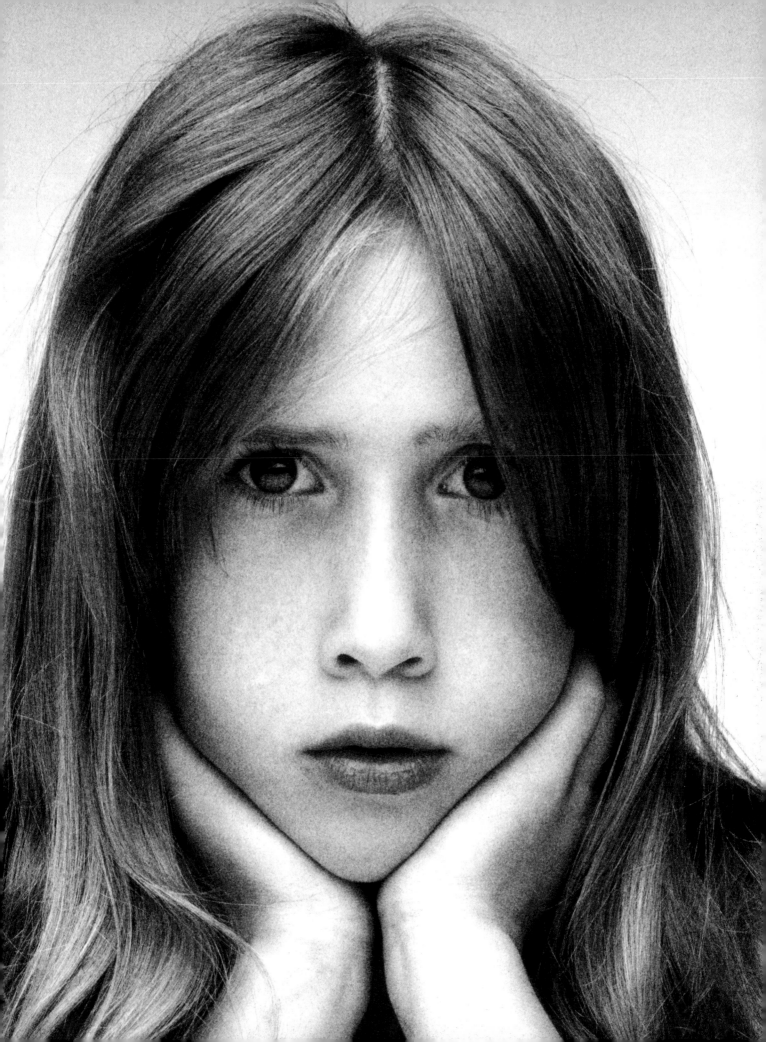

Understanding Exposure

Whether you are shooting in colour or black and white, accurate exposure is essential to the quality of your finished image. All cameras manufactured today, with the exception of the most basic point-and-shoot models, come with some sort of built-in metering system. The further up the range you go, the more sophisticated these systems become. For instance, at the cheaper end of the scale, the meter might just take an average reading across the whole frame, while on more expensive models, the metering system may offer you various modes such as average, centre-weighted, partial reading and spot.

A centre-weighted system means that the meter is reading for the whole scene but is biased towards the centre of the frame. Partial metering means that the camera reads the light over the central area, probably in the region of 8–10 percent of the total frame. Spot metering means that the camera reads just a small area, around three percent, at the centre of the frame. Digital cameras have an advantage over film versions because

you can look at the image on the LCD screen and study the histogram. This spreads the light levels over a scale in the form of a graph. If the levels are bunched to the right of the scale, then the shot is overexposed and if bunched to the left, it will be underexposed. An even spread of levels throughout the scale means that the shot is correctly exposed.

There are many situations when a camera's meter can give inaccurate results, because it is unable to read light like our brains. For example, imagine that you have positioned your subject in front of a bright window and they are wearing dark clothes. The camera's meter, if it is in the average mode, will read predominantly for the light coming in through the window and not for your subject. This means that they will come out underexposed. If, on the other hand, a subject wearing light clothes is placed against a dark background, they could come out overexposed because the meter will base most of its reading on the light reflected from the background and try to compensate for this by giving more exposure.

Varying exposure

OVEREXPOSURE 1. The exposure of a digital image is displayed as a histogram on the camera's LCD. The levels in this image are bunched towards the upper end of the histogram, or to the right of the LCD. This indicates that the brighter parts of the image are burning out and overexposing.

NORMAL EXPOSURE 2. The levels are spread evenly throughout the histogram showing an even range of tones. The levels bunched in the middle shows a good exposure for an average image.

UNDEREXPOSURE 3. The levels are bunched to the left and blocking in, showing underexposure.

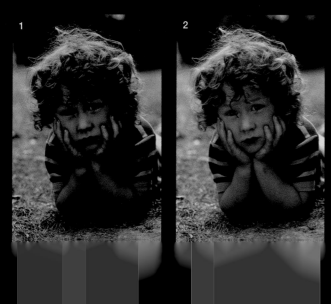

Far left: Often built-in exposure meters can get fooled into thinking that the scene is either lighter or darker than it actually is. In this shot, the meter has exposed for the shadow areas, resulting in slightly burnt out highlights.

Left: This time I took a reading from both the shadows and the highlights and created an average exposure. This has worked much better, with a far more even exposure overall.

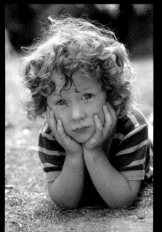

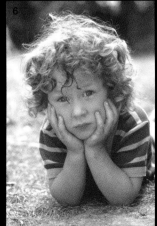

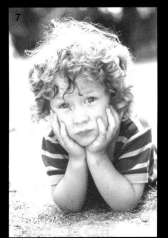

Left: In this series of exposures you can see the effect of bracketing. 1. This shot is too dark and is underexposed. By gradually increasing the exposure, the shot becomes lighter. 4. Correct exposure. 7. Increasing the exposure further results in overexposure.

Seeing in Black and White

For years, black and white photography came a poor second to colour. Perhaps the main reason for this was that, as the technology of colour progressed and demand increased, it became cheaper to manufacturer the films and have them processed and printed. Eventually it was more expensive to process a roll of black and white than colour, with some labs not even offering the service.

In recent years, however, black and white prints have been thought of as far more "arty" than colour and there is now a definite renaissance in the medium. Because black and white is a graphic interpretation of a scene rather than a straightforward record, the emphasis on texture, tone and composition is particularly important – even more so than in colour photography. It is easier to get away with faults when using colour because we perceive the world that way and our eyes therefore accept the image more readily. Black and white is alien to our normal way of seeing and technical imperfections are therefore harder to disguise.

Some digital cameras allow you to choose between black and white or colour modes when shooting the picture. Surprisingly, many models, even at the top of the range, do not have this useful facility. If this is the case then you have to create the black and white effect with a computer program such as Photoshop. You could do this by simply choosing the de-saturate mode, but the result will be less impressive than producing a duotone print (see pages 146–149). Digital black and white printing gives the photographer a far wider degree of control than the old wet darkroom and, with the ever-growing range of "art" printing papers, together with archival inks, the quality of the finished image can be unrivalled.

Good black and white photography depends heavily on shadow detail and a strong directional light will depict detail, such as the lines on a person's face, the bark of a tree or undulating desert dunes, to great effect. However, if the contrast between the shadows and highlights is too great, the picture will lack a range of mid-tones.

Left: Because we see the world in colour and can differentiate between one item and another quite easily, we need to learn how to see differently when we are shooting in black and white. The three coloured peppers stand out quite distinctly from each other when shot in colour. However, when shot in black and white, the red and the green have virtually the same tone and only the yellow one looks noticeably different.

Opposite: Texture is essential in black and white photography as it creates strong shadow detail, as can be seen in this decorative ironwork. Although it was painted an even shade of green, the light brings out the detail by creating contrast in the detail of the ironwork.

Composition

Although composition is crucial to a good photograph, it is surprising how many people give it such little thought. All too often they see a potential shot and just point the camera at it, never thinking that a different viewpoint, angle of view or background could improve the overall image and therefore composition.

The most basic adjustment you can make to the composition of a picture is in the way you hold the camera. Next time you take a shot, ask yourself if it is better viewed in the horizontal position (landscape), or in the vertical format (portrait)? It is amazing how something as simple as this is overlooked as it can make all the difference to the composition.

Another important consideration is the way the frame is filled. There is a common temptation to pack as much information into a shot as possible. The danger is that what should be the main focus of interest becomes submerged in a sea of distracting detail. Sometimes a photograph can be much more powerful because of its simplicity.

When composing your shot, it is worth remembering the golden section, or rule of thirds, as it is sometimes referred to. This involves placing an imaginary grid over the scene in front of you. Like a noughts and crosses design, it is made up of three horizontal lines and three vertical. The idea is that your main subject should be placed at one of the points where the lines intersect. It is a method that has been used by artists, architects and photographers for centuries and it really does help to produce well-balanced pictures that are pleasing to the eye. There is, of course, no need to follow this rule slavishly but it is a good starting point, especially in helping to decide where to place the focal point within a landscape.

On some SLR cameras, it is possible to change the focusing screen to an alternative one known as a grid screen. This is etched with lines that run horizontally and vertically so, when you look through the viewfinder, it makes the positioning of your subject according to the rule of thirds easier. Of course, the lines do not come out in your finished picture.

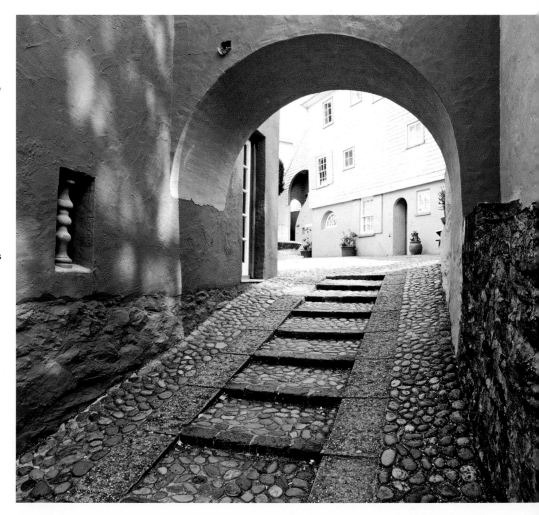

Right: The steps and arch in this shot are typical of the tools that the photographer can employ to create a strong composition. The arch makes a natural frame to the picture and the steps lead the eye into it and to the street scene beyond. Always explore all the available angles when composing your shots.

Opposite: Although this looks a simple shot, it took a lot of patience to get it right. The two boats were anchored in port and were gently drifting in the tide. I watched them carefully and noticed how they went backwards and forwards in the water, often forming a line or facing one another. I waited until they were at diagonals and then took the shot. This has created a pleasing Z like composition which did not exist when I first arrived.

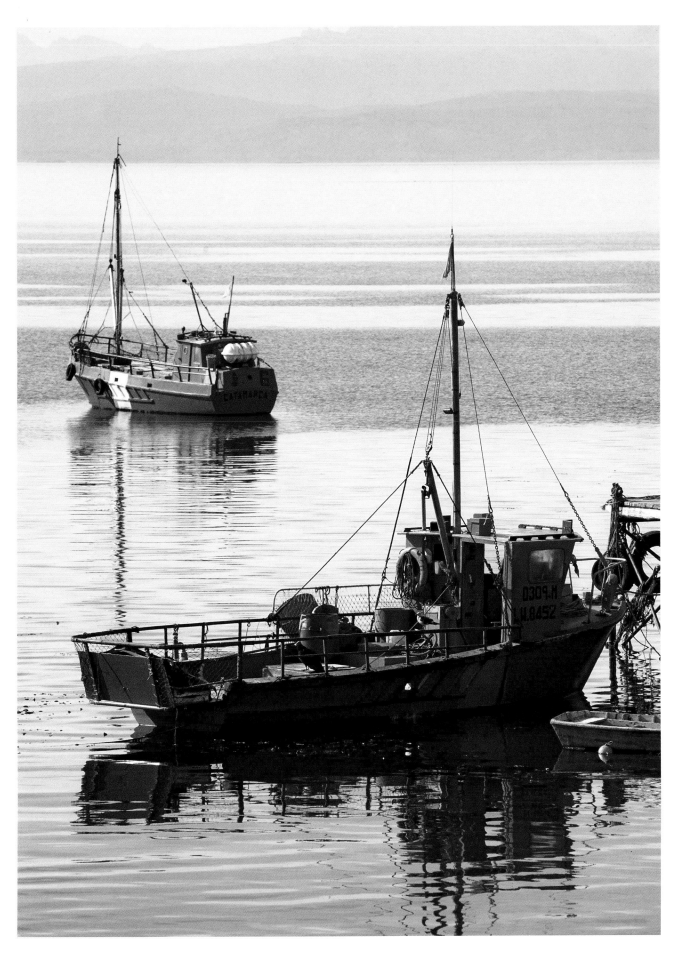

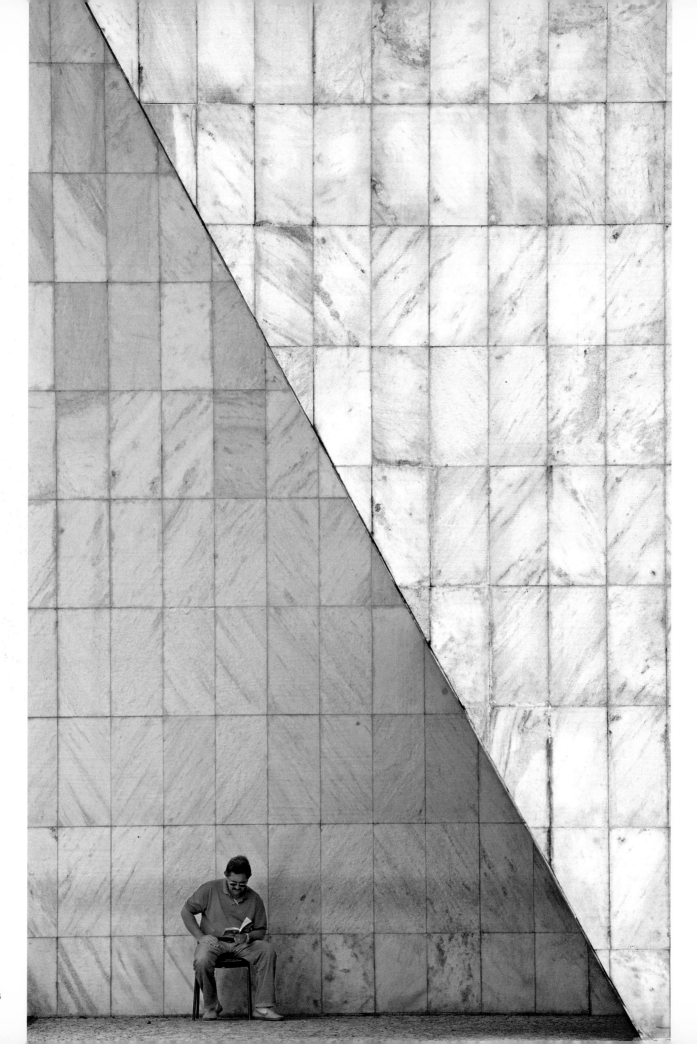

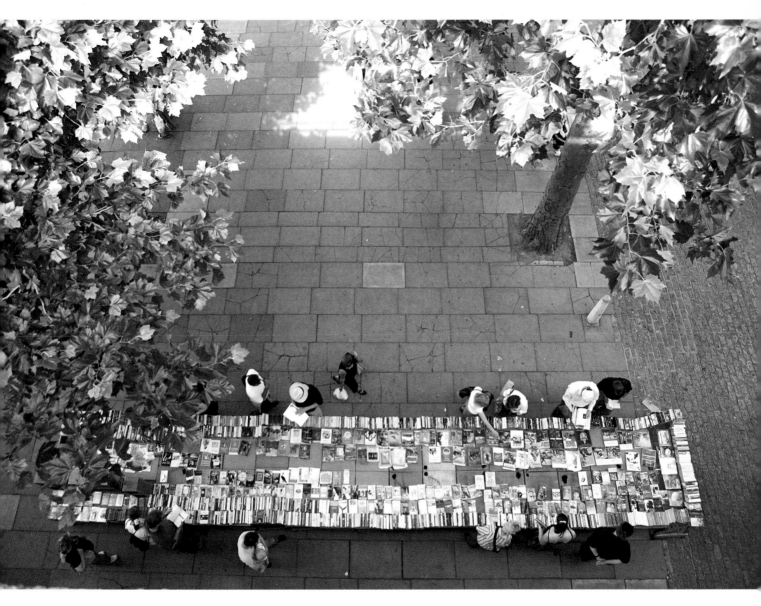

Opposite: I noticed this caretaker having a break from his duties and sitting in a recess of the building that was slightly shaded. The diagonal of the wall formed a perfect angle between the light and shade areas of the shot and worked particularly well in black and white. This angle, together with the stonework, makes a strong geometrical composition, using the minimum of detail.

Above: A good photographer is always on the lookout for a different angle. I noticed this bookstall from a bridge and became aware of the compositional qualities that the view presented. Even so, I had to wait for some people to walk out of the top of the frame to achieve this result. Studying all aspects of a composition and being patient is essential to making a good shot.

Foreground Interest

Many aspects go into making a well-composed picture and it is impossible to say that one is more important than another. However, if any are missing or badly conceived, then the overall composition and feel of the picture will be adversely effected. One such ingredient of a good composition is the attention given to foreground interest.

There are many ways in which you can use foregrounds to your advantage. An archway, for example, is a useful way of framing an image, leading the eye into the picture, besides being of visual interest in its own right. A tree, placed to one side of the frame with the branches spanning out along the top is another, similar option. These kinds of devices can also be used to hide unwanted detail such as a bland sky or electricity pylons in the distance.

Using "frames" such as this can cause problems with exposure. The background, i.e. through the arch or beyond the tree, might be in bright sunshine, but the foreground could be in the shade. In this case, the only remedy might be to return at another time of day when all parts of the scene are more evenly lit. If you are using a digital camera, another option would be to take two exposures, one balanced for the background and the other for the foreground. The two images can then be downloaded into the computer and joined together (see pages 114–117). If you choose this method, it is vital that each shot is taken from exactly the same viewpoint otherwise the finished picture will look unrealistic, so a tripod will be essential.

When composing your pictures in this fashion, a small shift in viewpoint can make all the difference. Exploring all the angles is essential, not just left and right but up and down. The lower you are, the less sky will be covered by the arch or the branches. The higher you go, the more will be covered.

Another way of creating foreground interest is to use a wide-angle lens. In this case you can choose a low viewpoint and slightly point the camera downwards so the foreground dominates the shot. This can greatly add to the dynamism of landscape images, sweeping the viewer into the picture.

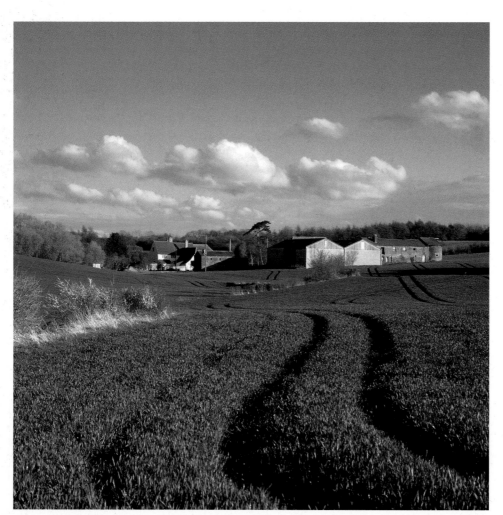

Left: When shooting in black and white, it is essential to look for strong shadow detail. When I took this shot in the late afternoon, the sun created deep shadows in the tractor tracks. By framing them in the bottom right of the picture, I have used them in the foreground to lead the eye into the shot.

Opposite: I used the same method when shooting these boats. The walkway meanders from the foreground to the centre of the picture. Without this feature, the foreground could have dominated the composition without adding any interest.

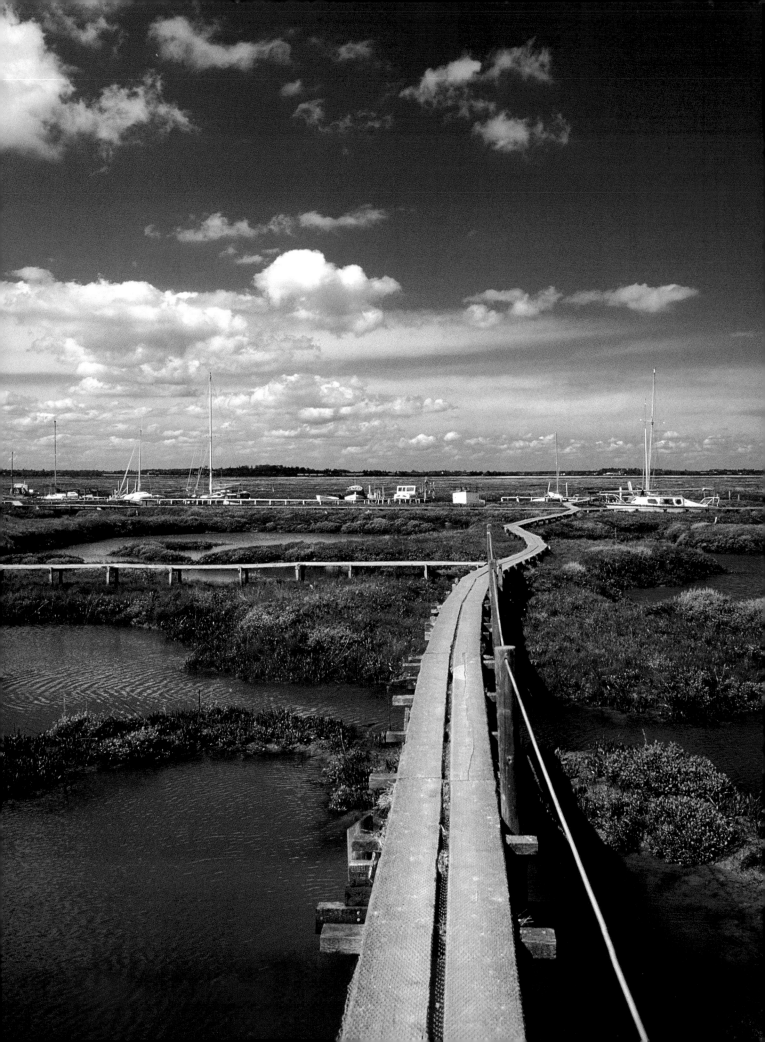

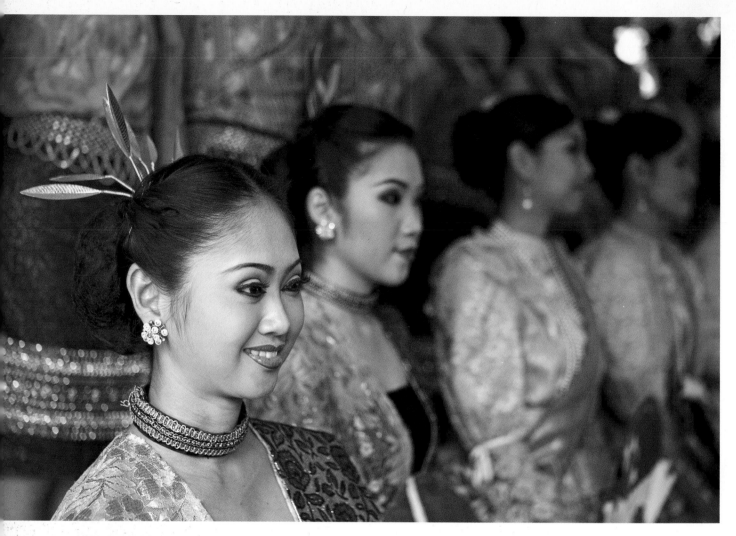

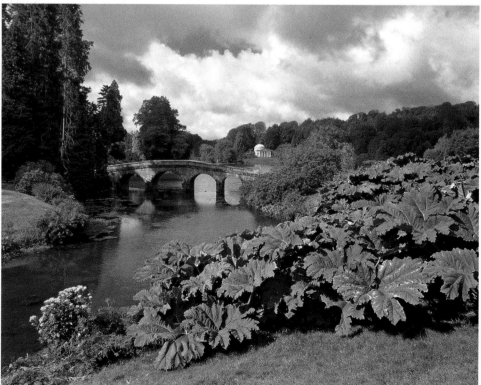

Above: Another way to create foreground interest is to use depth of field. In this picture I have focused on the performer nearest to the camera. By choosing a wide aperture, I have decreased the amount of depth of field, putting the centre of focus firmly on her while the other dancers, although visible, take on less importance.

Left: The giant leaves of these plants add foreground interest and also cover what would have been an uninteresting expanse of grass. Notice how the foreground is the important part of this shot, while the bridge and the small summerhouse in the distance add greatly to the overall composition.

Opposite: I used the arch in the foreground to make a frame for this picture. In situations like this, you need to make sure that the shot will come out evenly exposed, as it is quite easy to overlook the shadows that the frame can create.

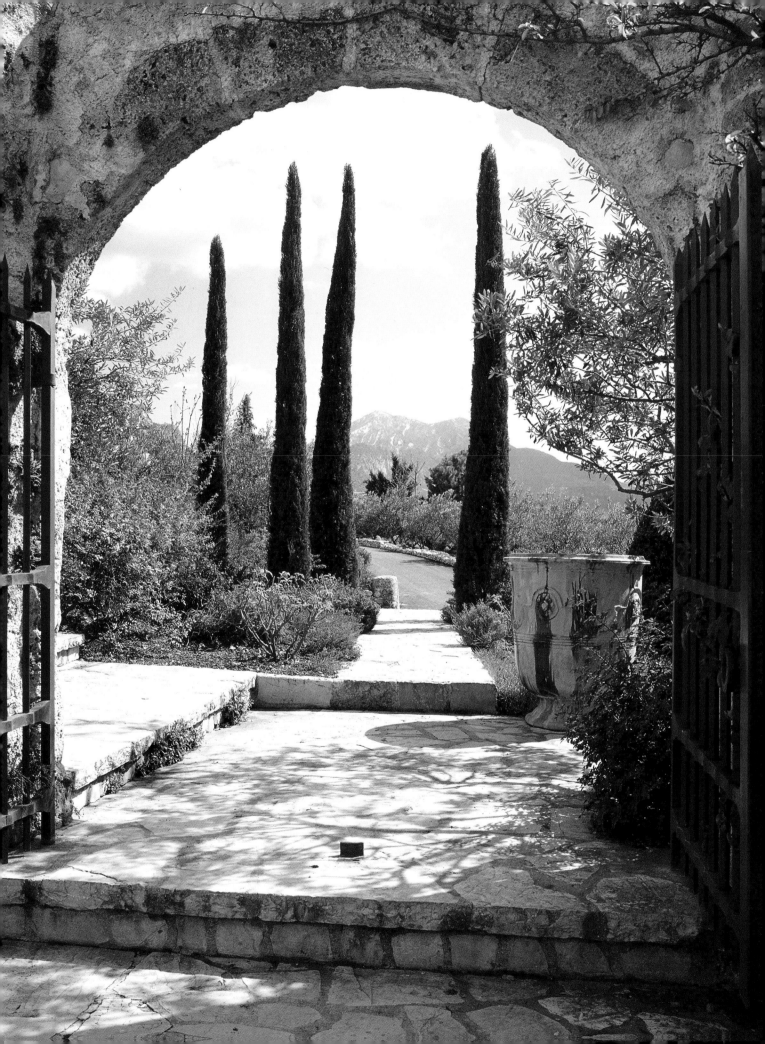

Backgrounds

Whatever your subject, the background will play an important part in the overall composition of your picture. Whereas the foreground can be used to lead the eye into the shot, so the background can be used to set off your subject. Try to imagine the background in much the same way as you might see a backdrop in a theatre. If the backdrop was inappropriate, then the actors could get lost in it and it would then be difficult to follow the play.

Many photographers believe that they have no control over the background, especially when shooting landscapes. While you can't change natural aspects of the environment, you can use your equipment to alter the perspective. For instance, if you are using a wide-angle lens, the background will appear to be pushed further into the distance. The more extreme the wide-angle lens is, the more obvious this effect. If you change to a standard or telephoto lens, the background will appear to come nearer. This can completely alter the appearance of your shot and can be achieved without even shifting your position. Another way you can use lenses to alter the background is to use a telephoto and combine it with a wide aperture. This will blur the background and render it neutral, making your subject, especially a person, stand out and become the focus of interest.

Good photographers often carry a notebook camera with them, perhaps a digital compact, which is used to record a potential backdrop for future images. This could be anything that catches your attention at the time, such as a weathered stretch of fence, the stonework of a building or a dramatic sunset. With digital photography, it is possible to shoot a range of backgrounds, which you can then drop your subjects into. Professional photographers are increasingly using this method as it cuts down on the, sometimes prohibitive, expense of having to take models away on location.

In photographic studios there will often be wide rolls of paper known as "Colorama". As well as black and white, these come in a wide range of colours, which can reproduce in black and white as an interesting range of greys.

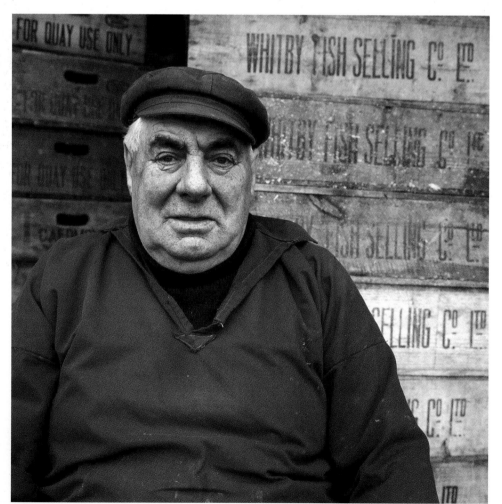

Left: When shooting people at work, it can be beneficial to include some reference to their trade. The boxes in the background of this shot tell us that the subject is involved with fishing. If I had photographed him against a plain background he could, for example, have been mistaken for an artist.

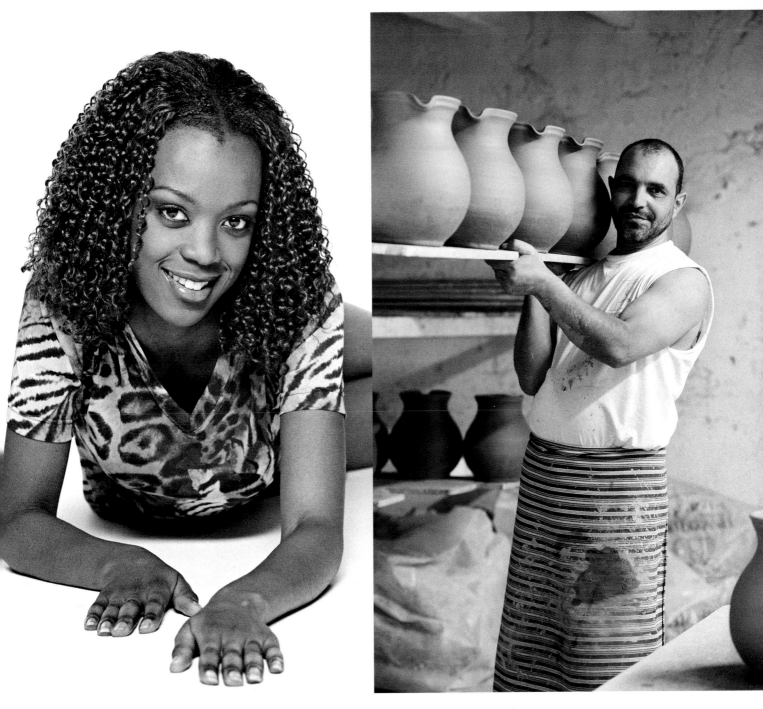

Above: In professional photographic studios there are backgrounds known as Coloramas. These are rolls of tough paper, approximately three metres wide and ten metres long. They form a seamless backdrop, as can be seen here, creating the effect that the background is infinite.

Above right: I chose to photograph this potter against a reasonably bland background as I wanted the emphasis to be firmly on him. The board ladened with pots that he is carrying adds to the compositional qualities of the picture and fills the background in the top quarter of the picture.

Overleaf: One of the reasons that I always carry a notebook camera with me, is that I never want to miss a shot. Here I just noticed this stone that was used to keep shut these shed doors. They made a great background and presented me with a ready-made still life photograph.

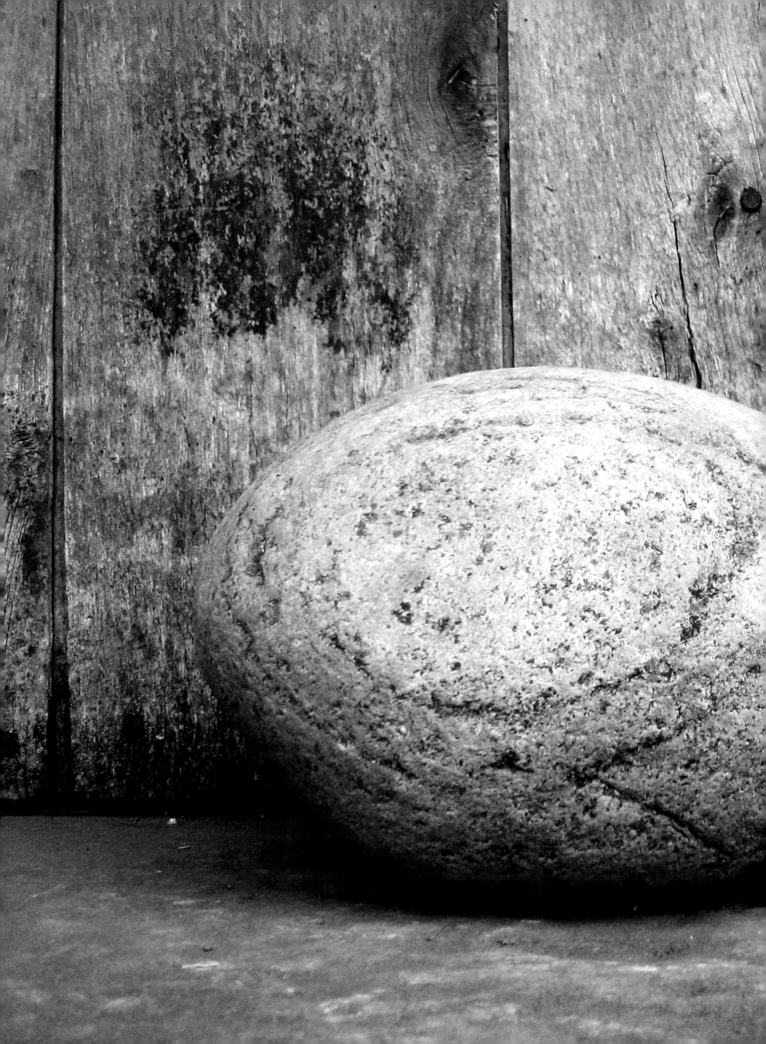

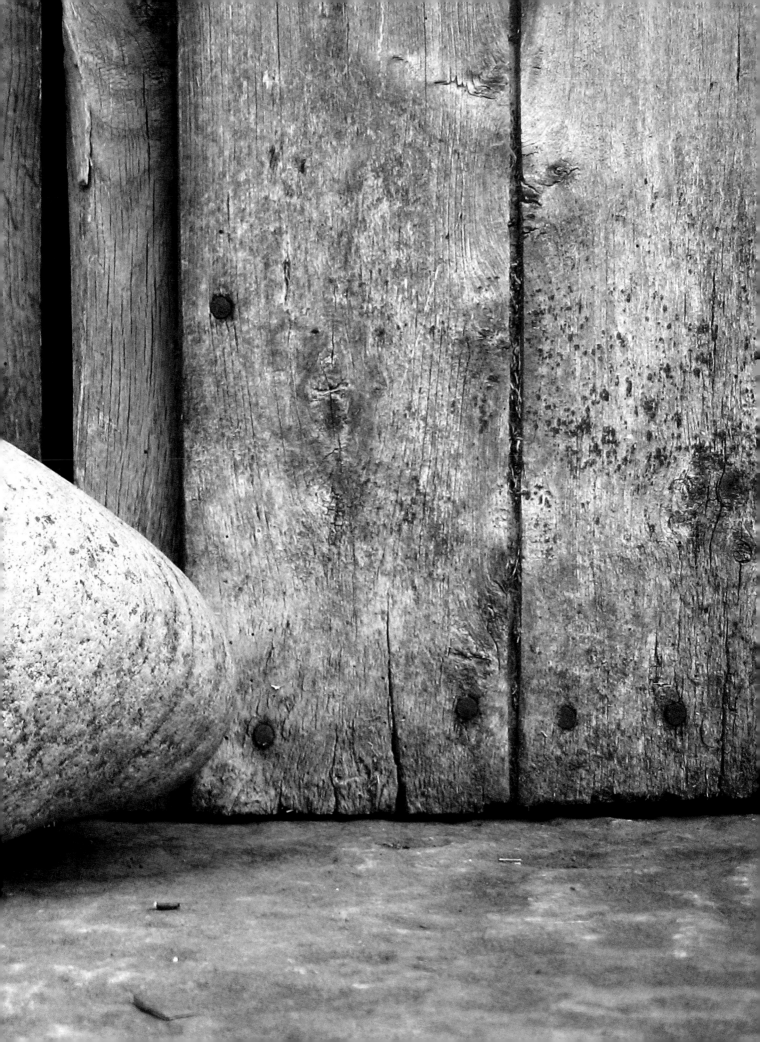

Against the Light

It is a common conception that the sun should always be coming over your left shoulder when taking photographs, but shooting against the light, or into it, can create a wonderful atmosphere. For this technique, however, it is critical to make sure the exposure is correct. This might seem quite obvious, but a camera's built-in exposure metering system can underexpose your shots quite dramatically, even turning the subject into a silhouette.

Many cameras have a backlight setting, which will compensate for this situation by giving more exposure than would ordinarily be the case. Alternatively, it might have a program mode for different situations including backlighting. Another way of balancing the exposure when shooting into the sun is to use fill-in flash on the subject. If you are shooting a portrait and your camera does not have these settings, nor do you have a flashgun with you, a reflector can be used to bounce light back onto the subject's face. This could be a purpose made one, or any kind of reflective surface, like a white table.

When shooting into the light, it is important to study your subject carefully and examine it from as many viewpoints as possible. Quite often, moving just a few metres one way or the other can completely change the atmosphere by reducing or increasing the amount of backlight. Remember that the sun is constantly moving, so that in the early morning or the evening, it will be much lower in the sky than it will be at midday and may be shining directly into the camera lens and causing flare. To avoid this, make sure you have fitted a lens hood.

Besides creating interesting shadows that will come directly towards the camera, backlighting can be used in a variety of other ways. For instance, it can be used to create a halo effect on people's hair. This always makes the scene look warm and sunny. Light shining through plant life also works well, making the veins of leaves look abstract and delicate. Look out, too, for backlighting on water. Whether it is the sea, river or lake, the highlights reflected from its surface can make strong graphic images, especially when the sun is low in the sky.

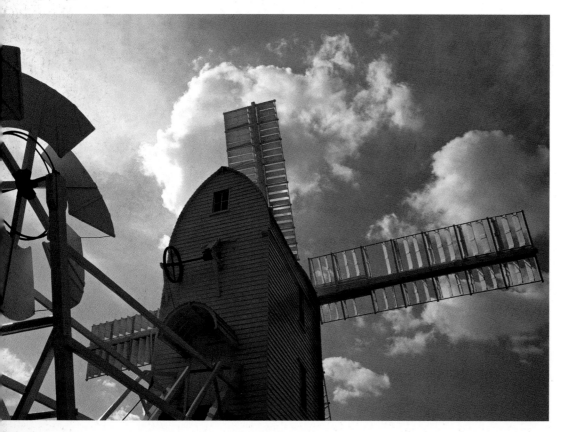

Left: Getting the exposure right is essential when shooting into the light. Here I wanted to record enough detail in the windmill to stop it becoming a silhouette, as I didn't think that it would make an interesting shape if it had gone completely black. At the same time, it was essential that the exposure for the sky recorded enough detail so that the clouds stood out.

Opposite: By deliberately getting as low as possible, I have used the leaves to fill the bottom of the frame. I looked directly into the sun and this has created a pleasing pattern of rays that fan out from the background. When shooting digitally in a situation like this, care needs to be taken as direct sun can damage the sensor of the camera.

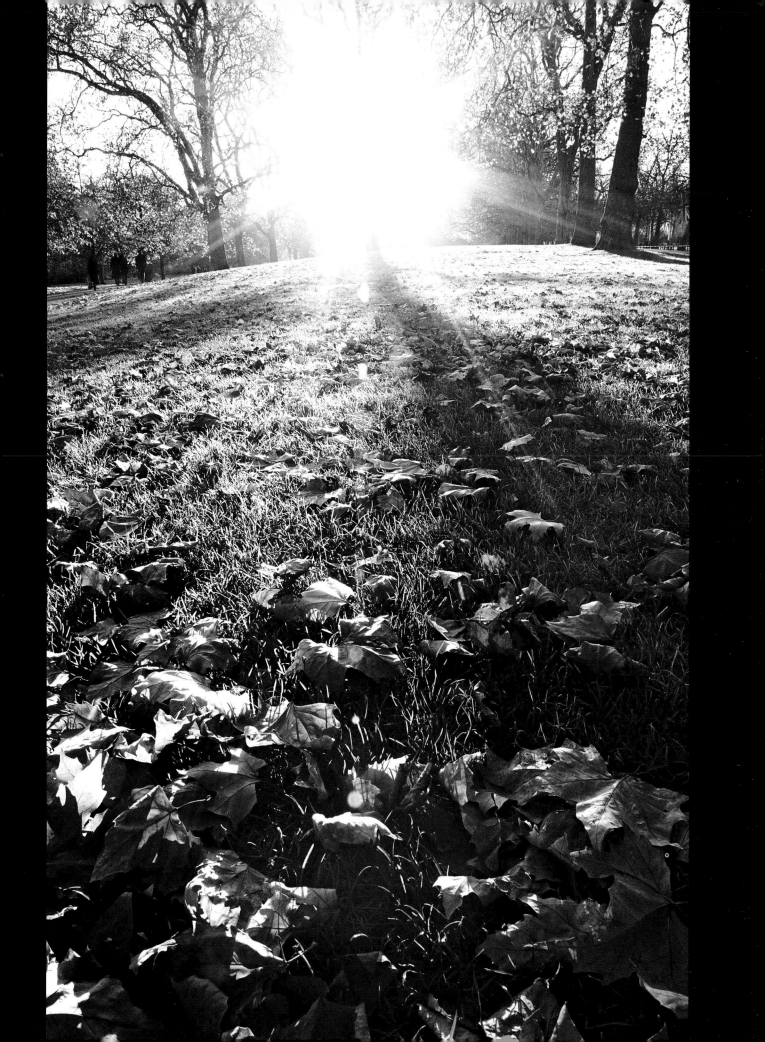

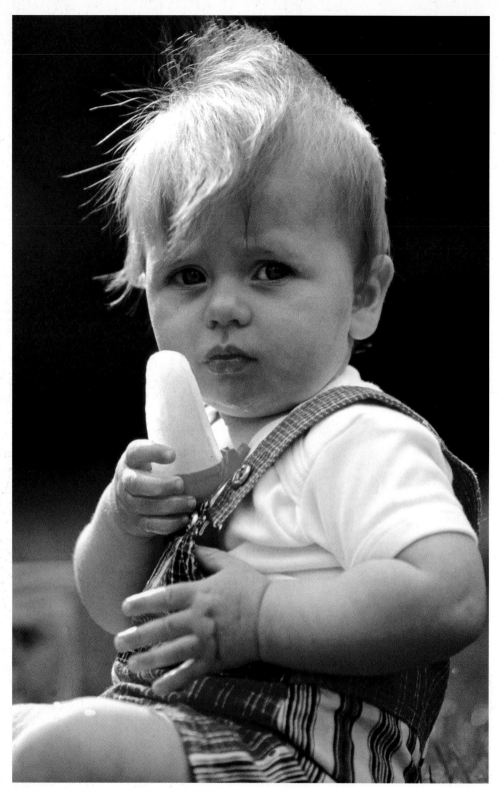

Left: In this portrait, the backlighting has created an attractive highlight in the child's hair. It has been given even greater prominence by having a dark background. Many cameras have a special mode for taking this type of shot.

Opposite, above: Plants make good subjects for backlighting. In this shot, the veins of the leaves are highlighted by having the sun shining behind them. I focused on the top edge of the leaf on the left of the frame and used a wide aperture to cut down on the area of sharp focus.

Opposite, below: I exposed for the highlights in this picture, which kept the surrounding areas dark and has made the grasses stand out well. The shot required a shutter speed of 1/500th second as the wind was blowing quite hard and I needed to "freeze" the grasses.

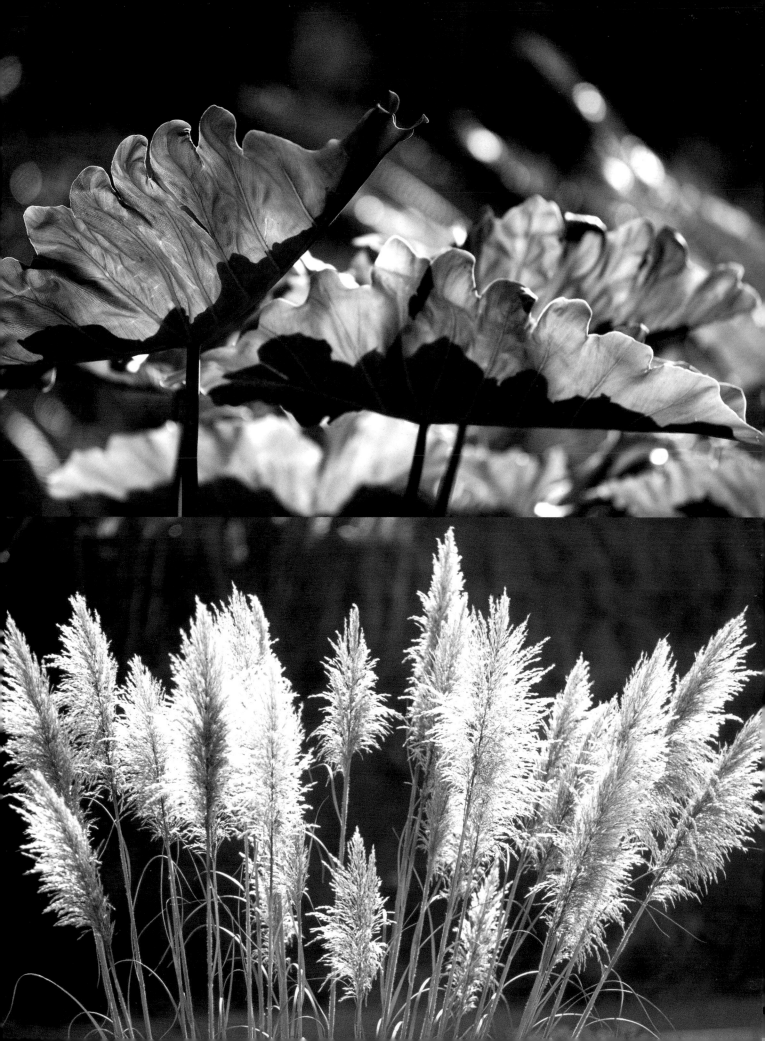

Texture

Black and white photography is the perfect medium for emphasising texture. This could take the form of an older person's skin that has been subjected to the rigours of an outdoor life. Alternatively, it could be a weathered piece of wood that has constantly been drenched by the sea and then dried in the sun, or a piece of rusted metal on which the surface is beginning to flake.

Pictures that have a strong texture content can lend themselves to being presented in an abstract way. This could be by contrasting up the original image, reducing its tonal range or enlarging just a small part of it so that it loses its natural form and identity. Another way that highly textured pictures can be used, is to present them as part of a montage or mosaic. Even the same image, printed one way and then reverse printed, can build a kaleidoscopic effect, which, when mounted together, can look stunning.

In black and white, the lines and fissures of such subjects will appear dark and strong; much more so than if they were shot in colour. To emphasise these features, it is best to use a strong amount of side lighting, which will make the shadows long and deep. Image sharpness is also important. If you are going to use a wide aperture, therefore diminishing your depth of field, you will need to make sure that the area on which the lens is focused is absolutely pin sharp. If you are also using a slow shutter speed, your shot might be affected by camera shake and look blurred. This will ruin the overall effect so it is essential to keep the camera still by using a tripod or some other means of support.

If you stop down to increase depth of field, it is important to remember that all lenses have an optimum aperture for ultimate sharpness. This is because diffraction – the bending, or spreading out, of light as it passes through a narrow aperture – reduces the overall image definition and resolving power (see pages 138–141).

When taking portraits, it is usually on an older person, who has led a physical outdoor life, where you will find the strong and weathered skin texture that will be best suited to this type of photography. Younger, more image conscious people may not thank you for portraying them in such a light! If you have taken your shots on film, use a high contrast developer and a harder grade of paper to emphasise the texture. Digital photographers can use the Curves tool in Photoshop to add more contrast to the image.

Left: Weathered wood, especially if it has been exposed to the sea, makes a great subject for black and white photography. The wood that this groin was made from has had its grain etched out, forming deep shadows that contrast well with its surface.

Opposite above: Metal is another surface that also weathers well when exposed to the elements. Strong sunlight was essential in creating the shadow detail required to bring out the interest in the texture of the various surfaces.

Opposite below: The tide had receded when I took this shot and had exposed the riverbed. It formed an interesting pattern of fissures that made a good foreground to the picture.

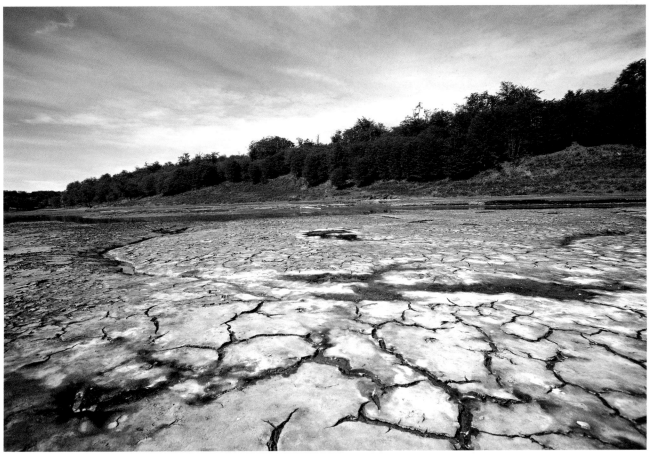

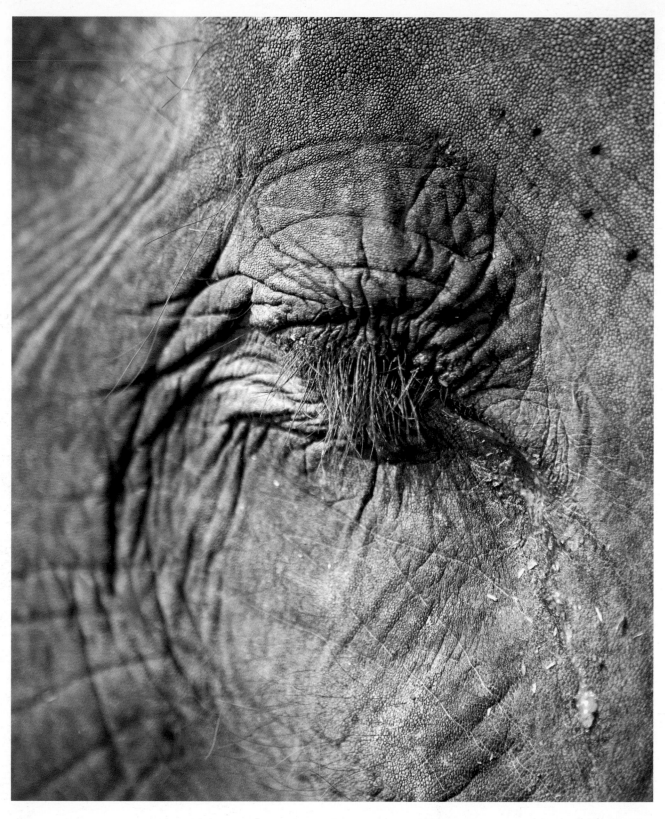

Above: I had been photographing this elephant when I noticed the quality of the skin surrounding its eye. I used a 200mm telephoto lens to get in as close as possible and the use of black and white has created a far stronger image than if I had shot it in colour.

Opposite: Older people often photograph better in black and white than they do in colour. This is because our faces become more lined and textured as we age. This quality is clearly visible in this shot, where the eyes have taken on a particularly weary appearance.

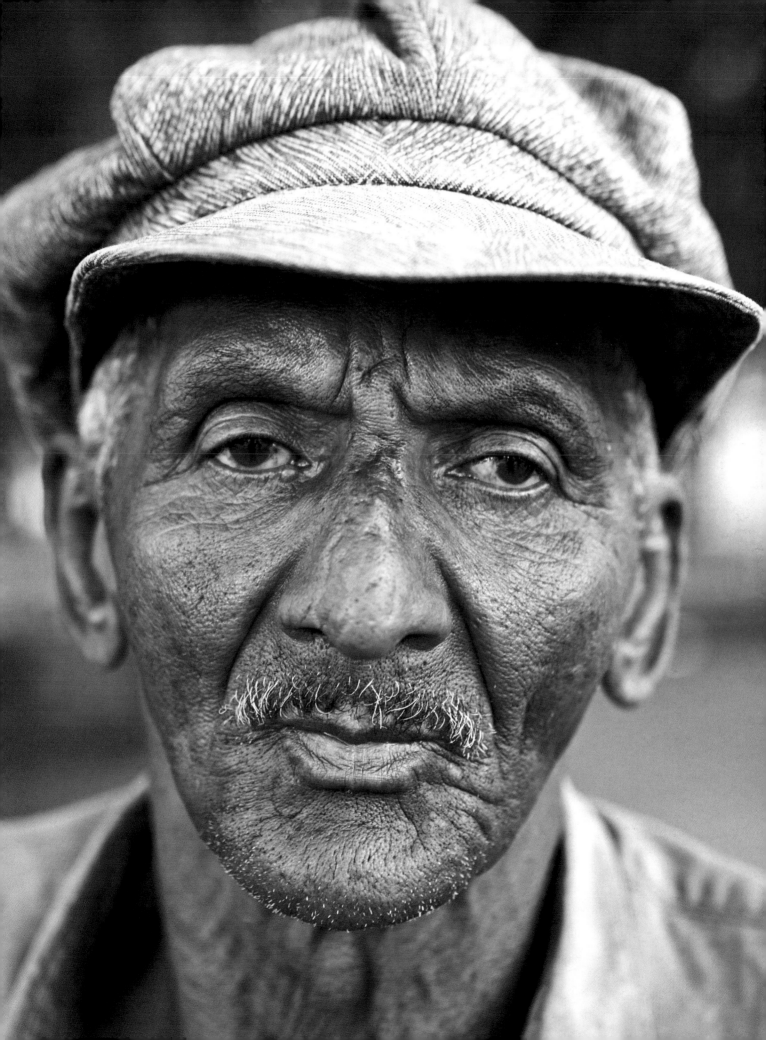

2 The Subjects

Portraits in Daylight

While daylight might seem the most natural light to take portraits in, it is potentially full of pitfalls. The most common of these is bright sun in the middle of the day, which can create harsh shadows, particularly under the nose, eyes and chin of your subject, and can make them squint and screw up their eyes. In this situation, it will be better if you can turn them round so that their back is towards the sun (see pages 46–49), or else move them to an area of overall shade where the light is more even and comfortable to work in.

An overcast day can sometimes be an asset when shooting portraits outdoors as there will not be any danger of harsh shadows. Because the light will be diffused, you will be able to position your subject virtually anywhere and still be confident of getting an even light.

If you are photographing a person who is wearing a hat, you will need to make sure that the brim does not cast a shadow over their face. At the same time, you need to be aware if other objects, yourself included, are putting your subject in the shade or casting a partial shadow over them. Look out, though, for patterns made by light and shade on the background or surroundings, which can greatly enhance the shot. These could be created by sunlight filtering through the leaves of trees or through a door or gateway.

Remember that the background plays an important part in photographing people outdoors. Besides making an attractive backdrop, it can be used to tell the viewer something about the character of the subject or the type of work they do. Maybe you could use a prop, like a tool or implement, which you can ask them to hold or lean on?

Although there is nothing wrong with placing the subject in the centre of the frame, especially if you are going in close, experiment with other positions. In magazines, you will often see the person has been positioned to one side. This is so that type can easily be placed over the opposite side. The introduction pages to this book illustrate this approach.

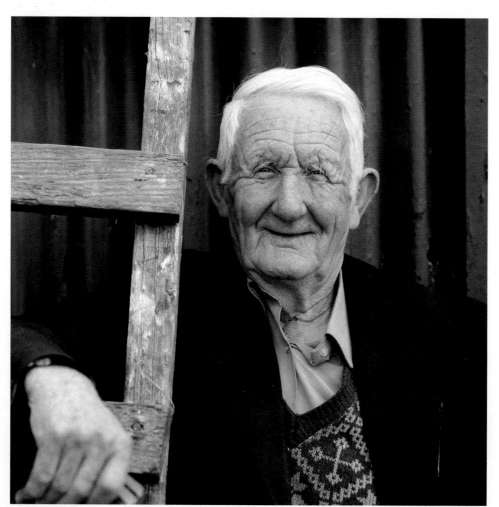

Left: As we have seen, older people photograph particularly well in black and white. Even though the daylight was quite subdued when I took this shot, the texture and detail of his facial features records well.

Opposite: By contrast, this girl's complexion is smooth and flawless without any visible age lines at all. However, her eyes are clear and bright and we are drawn naturally to them. A wide aperture has increased their prominence by putting the background out of focus.

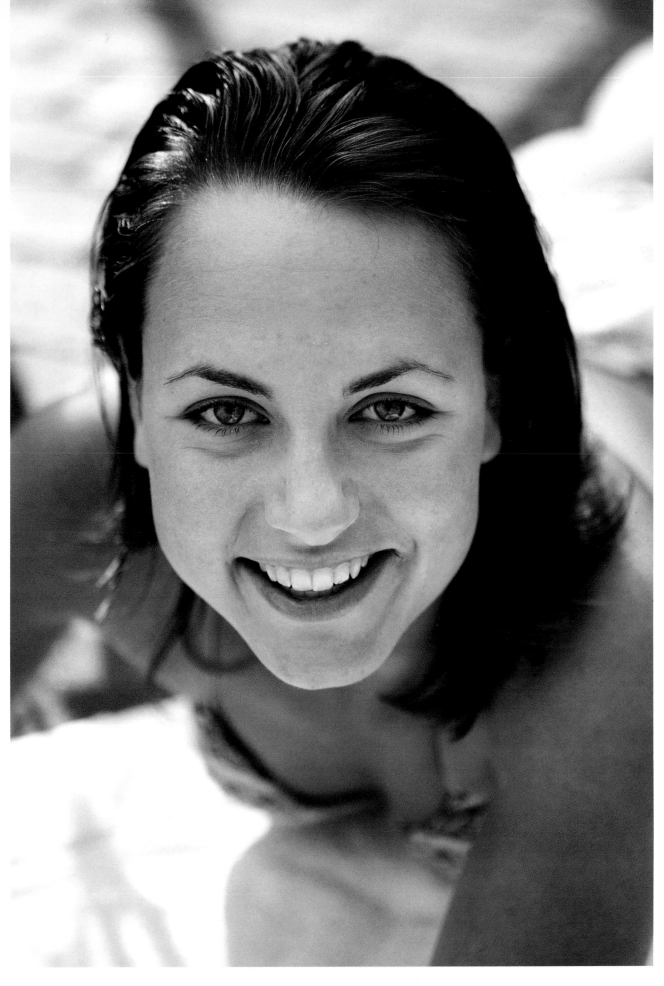

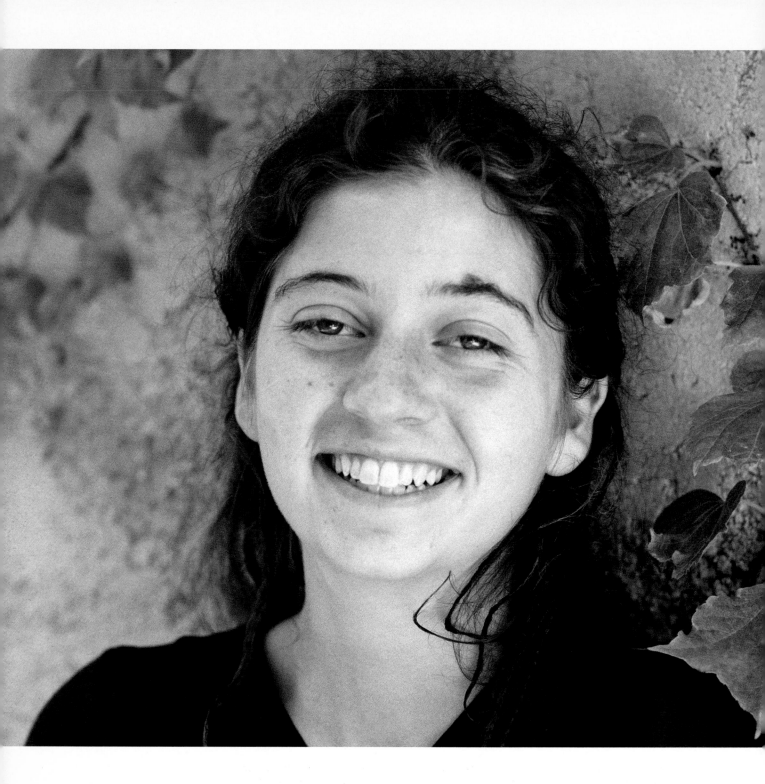

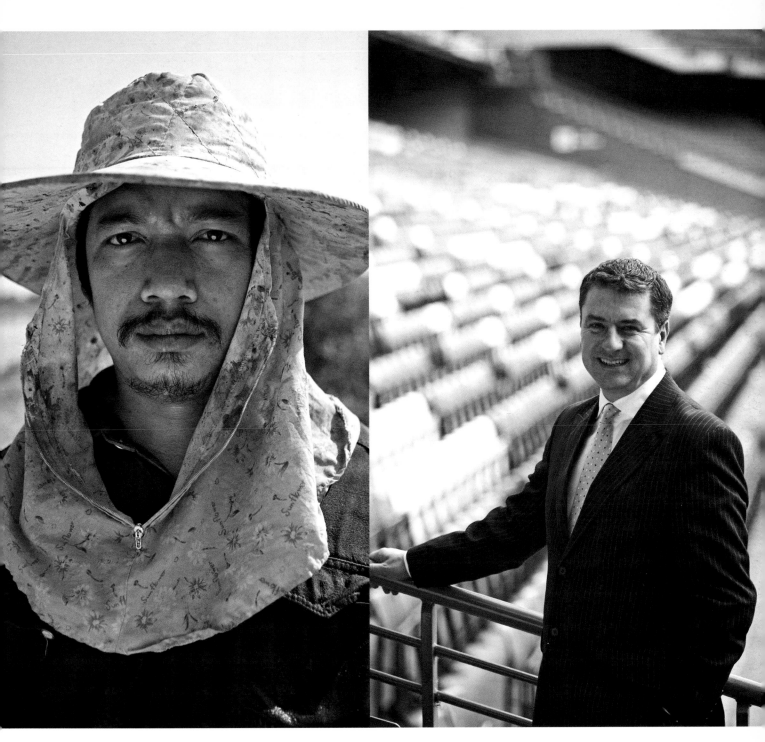

Opposite: When taking portraits in daylight, strong sun can create shadows under the eyes and nose and cause your subject to squint. If this is the case, try to move them to an area of overall shade, as I did here, where the light was much more comfortable for this attractive young woman.

Above left: Hats can cause lots of problems with shadows, especially if the brim is wide, as is the case here. I turned the fisherman round and used a reflector to bounce light back onto his face, creating a much more even light.

Above right: I used a reflector for this daylight portrait. With a 200mm telephoto lens, I could crop out the person, who was to the left of the subject, holding the reflector. The reason it was required is that he was shaded by the stadium roof, whereas the background was in full daylight, and so I needed to even up the two areas of the picture.

Portraits in Available Light

One of the benefits of shooting portraits in black and white when using available light is that you do not have to worry about colour temperature. Indoors, if the light source is tungsten, your shots would come out orange if you were using daylight-balanced colour film, or if a digital camera's white balance was set to daylight. Similarly, in fluorescent light, a green colour cast would result. There is no such problem with black and white as these shifts in colour temperature from different light sources are not applicable. This means that you can fully concentrate on the composition.

Available light refers to the light the photographer can use to take a shot without having to supplement it with an additional source such as flash. This could be natural daylight coming in through a window or doorway, or artificial light such as a table lamp, candles or street lighting. The advantage of composing pictures under this kind of light is that you can capture the atmosphere and mood of the environment, which could be destroyed if you were to use flash.

Normally, available light will be of a lower intensity than full daylight or flash, requiring you to use a faster film or to adjust your digital camera's ISO to a higher setting. This will increase the grain or noise (see pages 28–29), but you can use this to your advantage to enhance the atmosphere of the shot even further. The lower the light, the slower your shutter speed will have to be and so a tripod will be essential to keep the camera free from movement.

In the northern hemisphere, sunlight never shines directly through a window that faces north. This means that the light coming into the room will be diffused, with soft shadows, which is ideal for portraits. Naturally, if you are in the southern hemisphere, the reverse is true. If the light is coming from a direction other than the north, the chances are that it could shine directly through the window, creating harsh, unflattering shadows. By placing tracing paper, or a material such as muslin, over the glass, you can diffuse the light to give a softer quality.

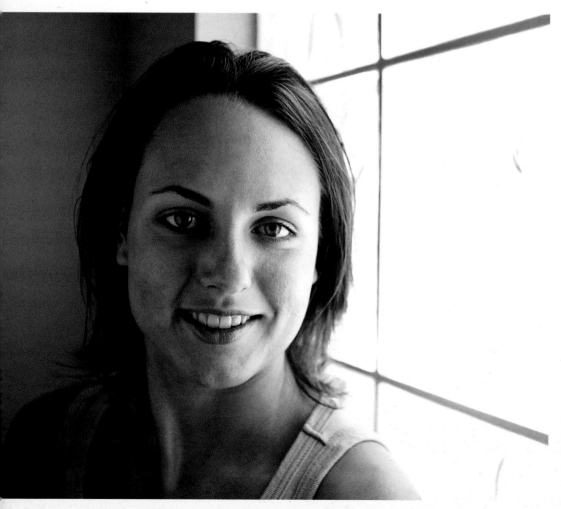

Left: I positioned this model against a glass brick wall. The daylight coming through was diffused by the thickness of the glass and gave an even illumination. I positioned a reflector to her left to bring out detail in the shadow areas.

Opposite above: In this shot, the model is entirely backlit. I chose to overexpose the background, which was a large window covered in muslin, to create a soft even light. To get the correct exposure for her face, I used a separate exposure meter and used the incident light method, which records the light falling on the subject and not reflected from it.

Opposite below: I had been photographing this actor when I noticed the row of lights in a restaurant. I asked him to go inside and shot him through the window. I used a wide aperture and focused on his eyes. The lights make an interesting line of perspective, besides providing the illumination for his face.

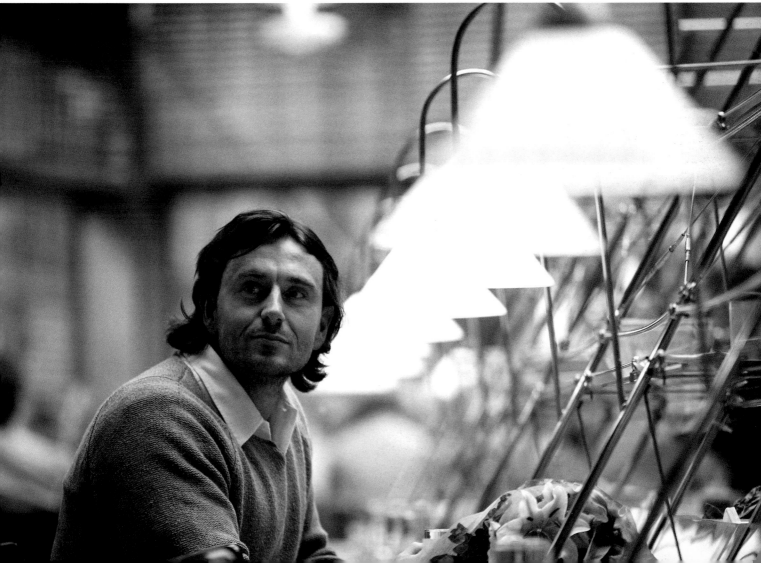

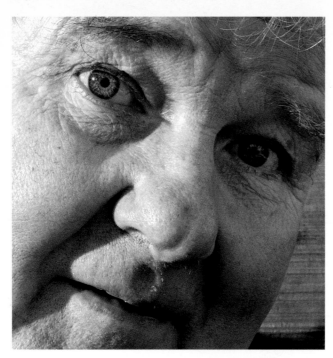

Left: I deliberately kept the light harsh in this shot as I thought it suited the subject. It has also put the emphasis on his right eye, which pierces the camera and gives him great presence.

Below: I took this shot of the two girls, who were lying on a bed, from a low angle. The white sheet that they are on acted like a natural reflector, bouncing light back up into their faces. This gave sufficient available lighting so that I did not need to supplement it with flash or some other light source.

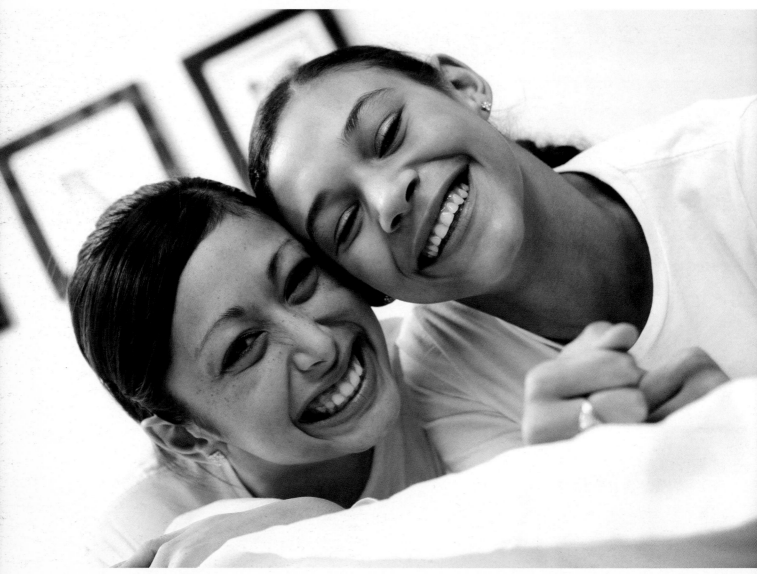

Right: Although this shot was taken indoors, the light is amazingly even. I cropped in tight on this traditional Thai dancer, which has created great eye contact with the camera. Flash would have ruined the ambience of the picture.

Below: The great thing with shooting black and white is not having to worry about colour balance. I shot this man in a room lit entirely with fluorescent light. If I had been shooting with daylight colour film, I would have had to filter the lens or, if digitally, adjusted the white balance to the fluorescent setting.

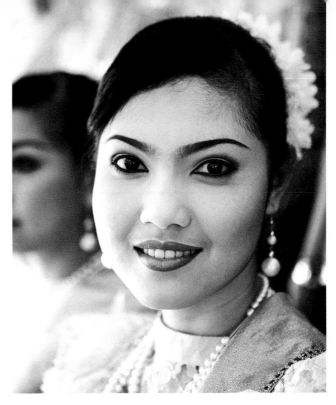

Studio Portraits

Taking portraits in studio conditions allows you to exercise complete control over the lighting. Unlike daylight, where the sun is constantly changing position, studio lighting will remain where it is set until you decide to move it.

Studio lighting does not have to be expensive. Units such as monoblocs can be bought as kits, consisting of heads, stands, reflectors and brollies, all contained in a custom, lightweight carrying case. The advantage of monoblocs is that

the pack that delivers the flash is contained in the head, making them very compact. All the controls for adjusting the power or the intensity of the modelling light will also be found at the rear of the head. These units come with different power outputs, the maximum being approximately 1000 joules. The lower-powered versions are cheaper but not so versatile.

The alternative to these is known as studio flash. These units have separate power supplies, which the head plugs into, and are far more powerful, with some delivering 6400 joules. Both these and monoblocs can be fitted with a range of reflectors, softboxes, honeycombs, snoots and so on. Some manufacturers offer a spotlight to which gobos can be fitted. These are pieces of metal that have perforations or shapes cut into them. When placed in the spotlight, they can be projected to create many different lighting effects.

A lot of photographers are daunted by studio lighting because they think many different lights are needed to shoot a portrait. While it is possible to use several lights in a set-up, portraits can be shot very effectively using just a single light source. In fact, if you think of a single head fitted with a large softbox, there is no reason why you cannot recreate the type of available window light that is described in the previous section. It is not without reason that softboxes are sometimes called window lights.

Besides fitting the head with a softbox, you could use a standard reflector fitted with a honeycomb. This produces a much harsher directional light with very little spill. Another attachment is a conical-shaped reflector called a snoot. This creates a small circle of light and its diameter can be adjusted by moving the light nearer or further from the subject. There are many more different lighting attachments available and, together with some poly-board reflectors and mirrors, a whole myriad of effects can be achieved from just one light source.

Left: I used a studio flash fitted with a large softbox for this picture. I also placed a reflector either side of her and one more under her chin. This has created a very soft and even light, allowing her striking eyes to shine through.

Left: I used one light with a round dish reflector at right angles to this model. I then placed a large poly-board reflector on the opposite side to soften the shadows. Two lights were directed towards the background to make it perfectly white and adjusted to the correct balance so that they did not cause flare.

Above: I used a top light on this model and then a silver reflector under her chin to bounce light back onto her face. This has created a harsher light than would have been the case if I had used a white reflector. Always study carefully the effect that any reflector has to make sure that it is appropriate for the feel you are trying to capture.

Above left: I used black velvet for the background in this picture, which gives a rich black. I positioned one light to the left of the boy and then used a white reflector to his right. This can be clearly seen reflecting in his eyes.

Above right: I used a similar lighting set up for this shot but decided not to use a reflector on the opposite side. This has created a much harsher light but gives the model far more character and personality.

Nudes Indoors

Photographing the nude indoors can be a more relaxed experience than shooting outdoors on location. You will not be at the mercy of the weather, you can control the light and have everything you need readily at hand – not to mention the assurance of privacy.

It will really pay to plan ahead by working out the type of shots you want to take. This will save time when the shoot is under way and, with a clear idea of your aims, you can concentrate on trying to achieve the best possible results. Sometimes it helps to make a series of small sketches of the type of poses you are after, in the form of a storyboard. This may sound like a rigid way of working, but it means you can confidently get the session underway without delay. If things arise that deviate from your plans, then you have the comfort of exploring a new avenue, reassured that you can return to your original idea if it doesn't work out. There is nothing worse than long silences with the model while you ponder over what to do next. You need to appear confident, professional and in control.

Practical considerations are also important to make the session run smoothly. The environment should be warm and comfortable with a range of music to hand. It is amazing how the right music can enhance a session whereas the wrong choice can frustrate it. Have supplies of tea and coffee as well as soft drinks or water available. The way to get the best out of models is to make sure you have considered their needs.

If additional lighting such as flash, tungsten or HMI is required, set this up as far as possible beforehand. If you plan to shoot in the bathroom, take care that any additional lighting you use is safe. You will also need to make sure that your camera lens doesn't get steamed up or splashed with water. Always be on the look out for a different angle and be prepared to explore alternative viewpoints.

Digital cameras have the advantage that you can download your shots and view them on the computer as you go along. This can help you to explain to the model any subtle differences you are trying to achieve in the pose or expression.

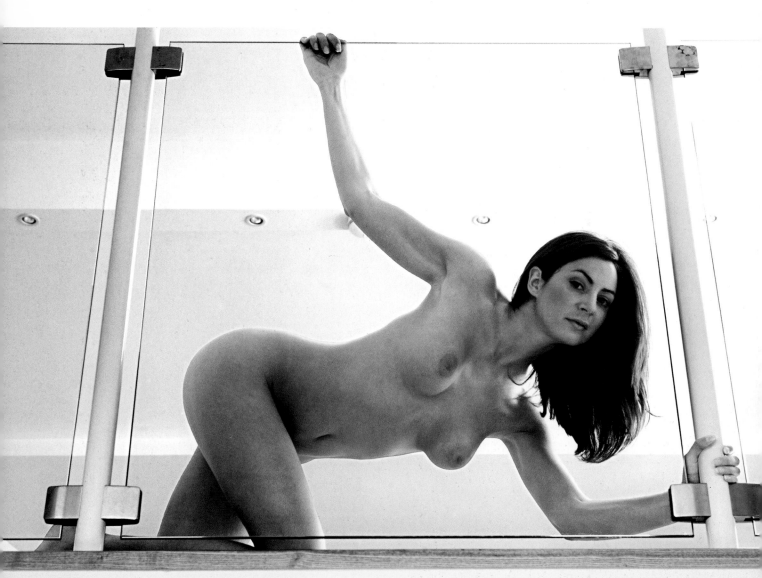

Left: I wanted to introduce a degree of symmetry into this picture so I got the model to position her hands and legs evenly. The receding staircase makes an interesting backdrop and the shot was lit by available daylight.

Opposite: I always like to explore different angles and took this picture looking up to the mezzanine floor of a loft apartment. A large skylight can be seen in the top right hand corner of the shot and this provided most of the light. The glass balustrade provided an interesting feature for the model to pose behind.

Below: I used a single studio flash for this portrait of a heavily pregnant woman. I positioned it behind her and then used two reflectors in front to bounce light back. This has bathed the contours of her body in attractive highlights and the high viewpoint adds a further degree of interest.

Overleaf: The light for this shot was coming from the left hand side and I used a honeycomb over the dish to make the light more directional. The background was left unlit and picked up what little spill there was, and this has created a moody, low key image.

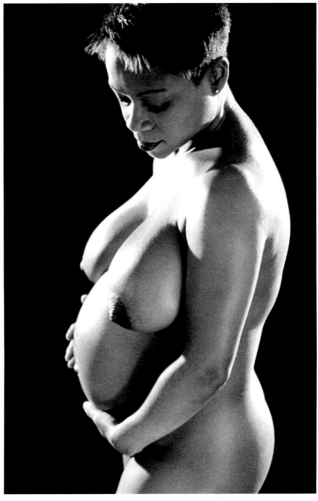

Nudes Outdoors

While shooting nudes outdoors involves more of a risk with the weather and light, the rewards can more than compensate for this. Many photographers of the nude also have a passion for landscape and relish the challenge of combining the two in a way that is complimentary and natural-looking.

Finding suitable locations is the first step in planning a shoot. It is best to do this in advance, without the model present, to avoid wasting time through indecision. Take a digital compact camera with you on these recces, so you will have a visual reference to help you think through possible poses and compositions. Beaches, riversides, woodland and fields could all be potential locations as could, if you are feeling brave, urban environments. It is advisable, though, to choose a spot away from prying eyes. This entails trying to avoid the school holidays and finding an area off the beaten track. It's not fair on your models if they suddenly find an audience ogling them and, besides, it only needs one person to be offended and call the police for the entire session to be brought to an abrupt end.

The golden rule of shooting the nude outdoors is: be prepared. Unlike shooting indoors, where all equipment is at hand, you will have to take everything you need along with you. This does not mean loading yourself down with every item you own, but rather that you really think about the type of shots you are going to take and what will be essential for them. As well as the camera and lenses, spare batteries and compact flash cards (for digital users) should be top of your list. Make sure that your model is comfortable and that it is not too cold. Nothing is worse than skin covered in goose bumps or that has turned blue with cold. Request that tight clothing is not worn before the shoot as it will leave unsightly marks on the skin.

The light will be vital to the success of outdoor nude photographs as the strength and direction of it will have a great

bearing on the mood of the image – warm and sensual or cool and erotic, for example. Of course, even if you have studied the weather forecast and timed your shoot accordingly, nature always likes to throw in some surprises from time to time, so be prepared to change your original ideas to make the best of the circumstances.

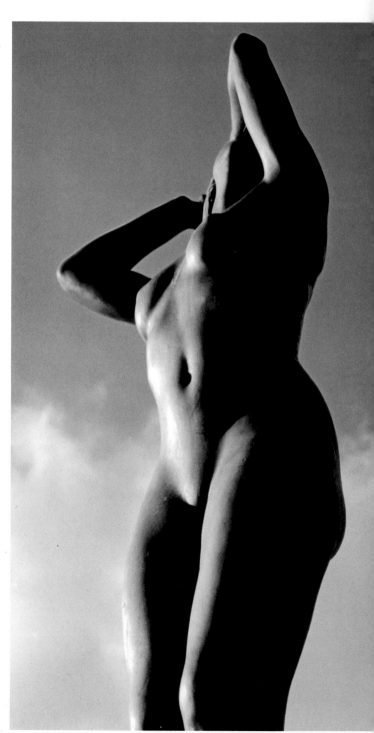

Right: I often find that sculpture provides a wealth of inspiration for nude photography. For this reason I always carry a compact digital camera and use it as a notebook. I can then refer to it later and use the shots as the basis for particular poses when shooting live models.

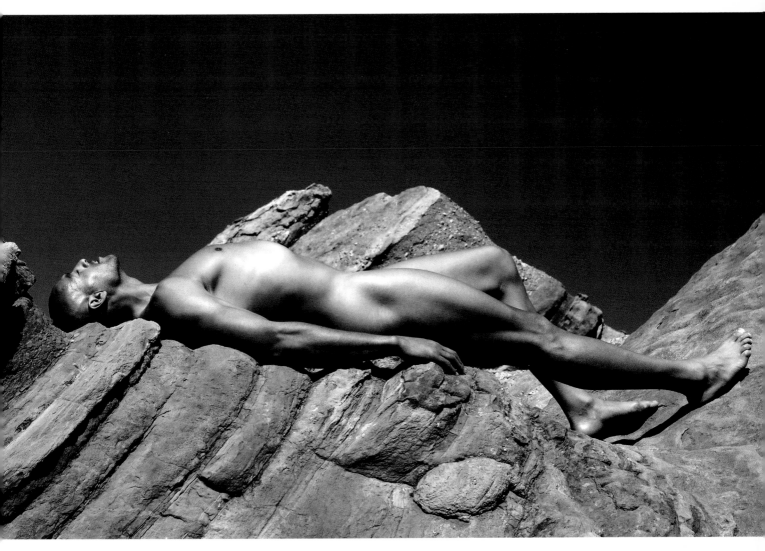

Above: Posing models outdoors needs careful thought. I positioned this male model so that the rocks in the background blended well with his body and so that his left knee echoed the lines of the rocks.

Right: This model has adopted a classical pose in this outdoor situation and the overcast day has created an even light. The lines of the decking add a natural perspective to the foreground and the background is unobtrusive.

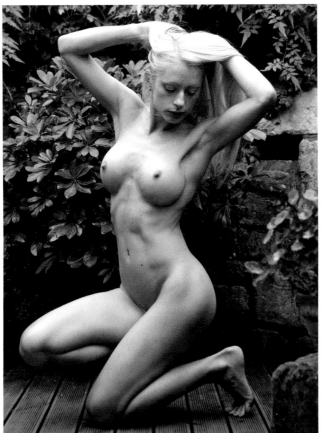

Overleaf, left: I used a 200mm telephoto lens for this shot and chose my viewpoint carefully so that the silver birch trees made a natural line, stretching into the background. The model's pose and expression have captured that element of surprise.

Overleaf, right: I deliberately chose a very low angle when I took this shot. This has given the model great presence and height. When posing models in situations such as this, you need to take care that the rocks do not make unsightly marks on the skin, which might then take hours to retouch.

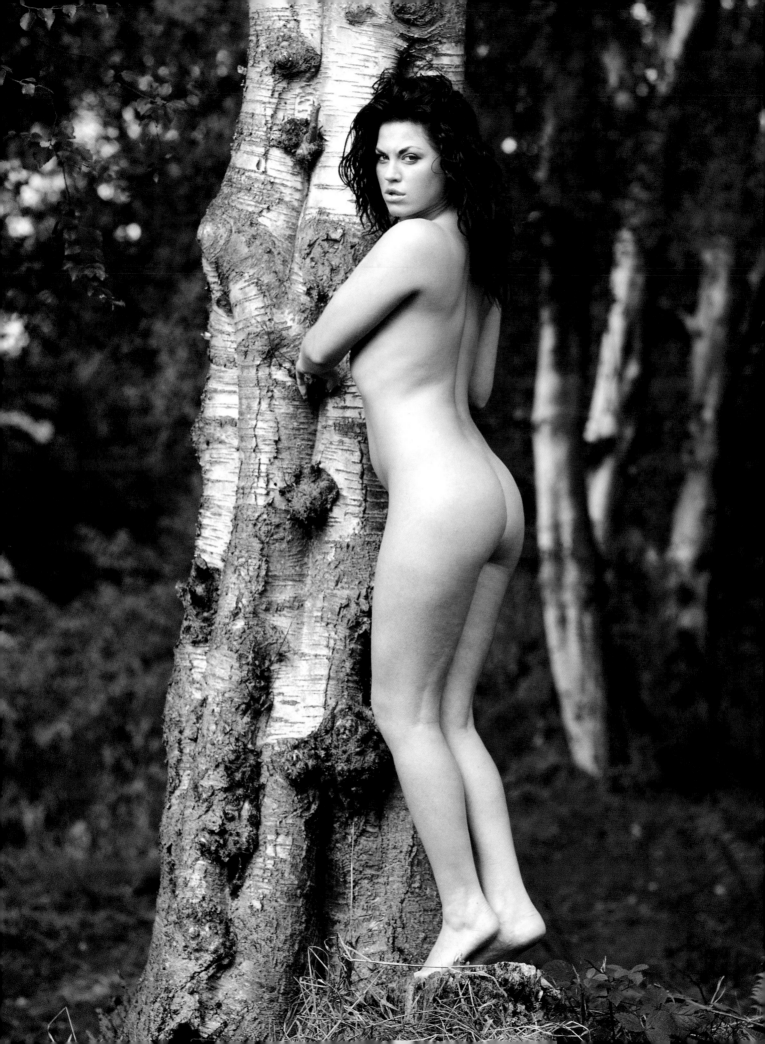

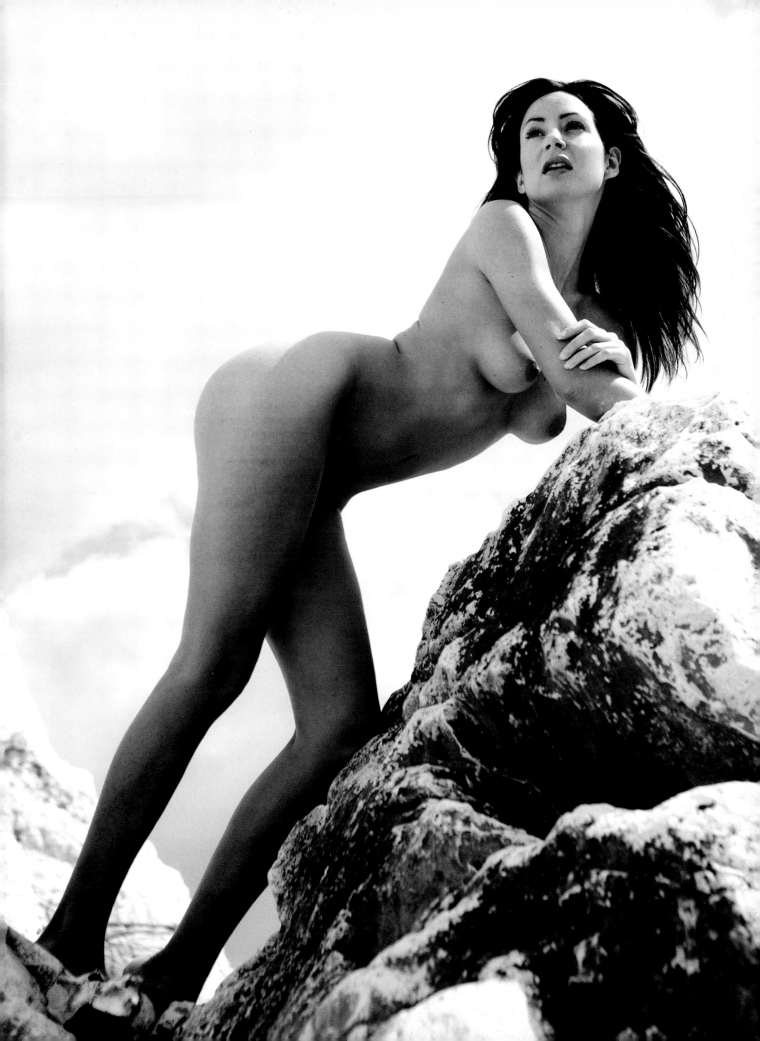

Landscapes

Anyone who is familiar with the work of the American photographer, Ansel Adams or the English photographer, Edwin Smith, to name but two, will know just how **powerful a good black and white landscape picture can be. Much of their work was taken on bulky 10 x 8 cameras that were heavy enough in the confines of a studio, let alone halfway up a mountainside. The quality of their prints was second to none and those by Adams still sell by the million every year.**

Unlike colour photographs of landscapes, which can be easy on the eye and therefore possible to hide technical faults, black and white landscapes stand or fall totally on the merits of their composition, tone and print quality. Good monochrome prints have a timeless quality and, with the technical innovation of digital printing and the wealth of different papers available, everyone is now capable of producing exhibition-quality prints for display, either in albums or for hanging on the wall.

Besides photo quality papers, there are an ever-increasing number of rag papers with different surfaces. Some of these have archival permanence and can reproduce your best images with a quality that many photographers now think surpasses traditional bromide printing. If you are shooting on film, choose a fine grain one. ISO 100 would be ideal, as this will reproduce a wide range of tones and allow you to enlarge the image to beyond A3 without pronounced grain.

Filters will play an important part in enhancing black and white landscapes (see pages 122–125). A yellow filter, for example, will help to retain detail in a sky and bring out the clouds so that they appear with greater clarity. If you want a really moody, stormy-looking sky, then a red filter will darken it. Graduated neutral density filters are useful for detail in the sky, while at the same time allowing for correct exposure of the foreground.

If you are shooting digitally, you can convert your images to black and white once you have downloaded them into your computer. There are numerous post-production techniques, such as toning (see pages 146-149), you can employ with a program such as Photoshop. Used subtly, this type of enhancement will give a real professional quality to your prints. The same applies to landscapes shot on film, as your negatives or transparencies can be scanned and then converted to black and white on the computer.

Opposite top: When taking pictures of landscapes, there can often be a discrepancy in the exposure. The foreground and hills nearly always require more exposure than the sky. In this case, I used a graduated neutral density filter to keep the detail in the sky and retain the clouds.

Opposite bottom: By taking a low viewpoint and using a 24mm wide-angle lens, I have created a shot that gives the feeling of expansiveness. The horizontal lines of the crops in the distance, provide the perfect base for the hills and building to sit on.

Left: By using a telephoto lens, this shot has been slightly compressed. This means that there is a certain amount of foreshortening to the foreground and that the background has been drawn closer to the gate. Overall, this has created a tight composition.

Right: By contrast, I used a wide-angle lens for this snow scene and it has very slightly elongated the picture. The track adds strong perspective and the sunshine – nearly always essential in pictures of snow – gives interesting shadow detail.

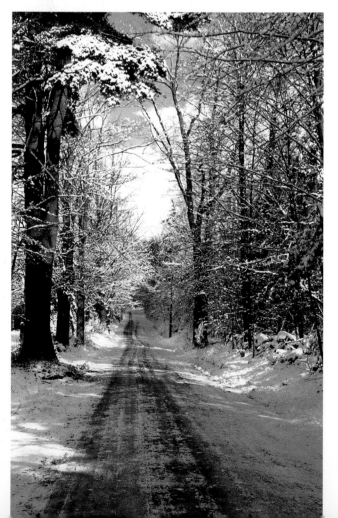

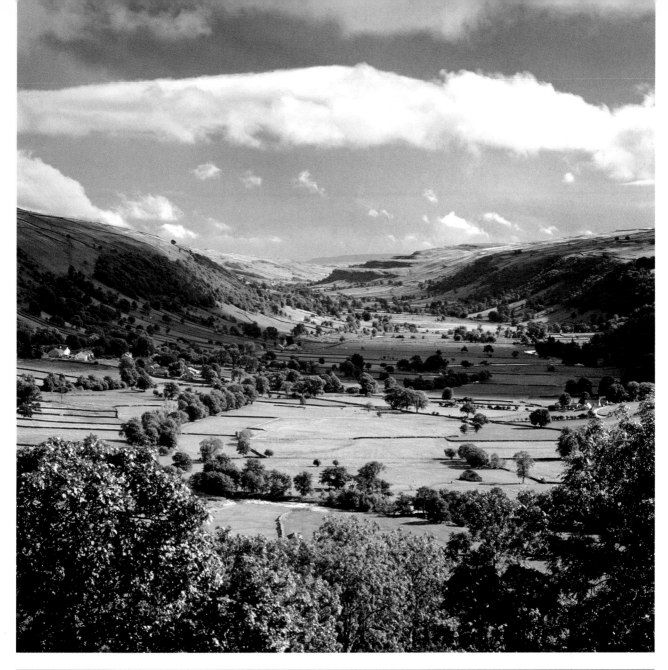

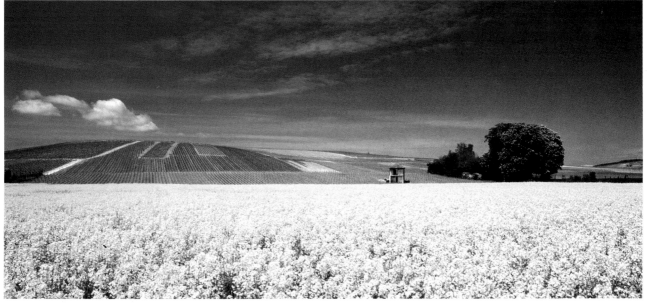

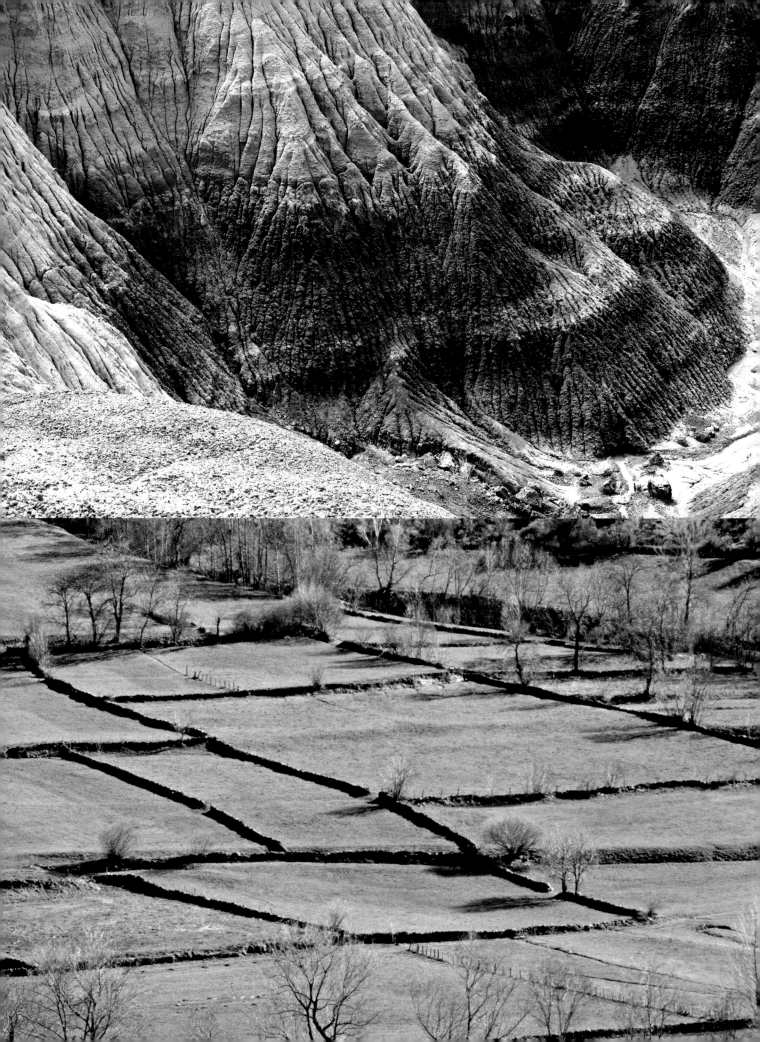

Opposite top: The texture of these hills makes an interesting shot in the sense that they almost could be mistaken for a prehistoric animal's foot! Even in the biggest landscape, you can nearly always find an area of interesting detail if you frame the shot properly.

Opposite bottom: I took advantage of the late afternoon sun to capture the strong shadow detail. This has given the impression that the stone walls, which divide the field, look as though they have been drawn on the surface, creating a strong graphic element to the shot.

Above: The dappled light in this shot works well, creating pools of light and interesting highlights. Overall the shot has a good tonal range and a great feeling of perspective, created by the receding trees and the track.

Rivers, Seas and Lakes

Rivers, seas and lakes make great subjects for photography and, as there are very few places in the world that aren't close to some form of water, they are within the scope of all photographers. However, there are some mistakes that many photographers consistently make. Using a wide-angle lens needs careful composition and framing. It is all to easy to end up with vast swathes of foreground without any visual interest, while the background recedes so far that little detail is visible.

Skies, too, if overcast and without cloud detail, can look bland and ruin your shot. This is why foreground detail is so important. Look for an area that will fill the bottom of the frame, such as rocks and pools, or an interesting pattern in the sand if you are at the beach. A piece of driftwood could add interest, or if trees fringe the beach, these could be put to good use to frame one side of your shot.

If you are photographing a river, consider how to make the flow of the water look interesting. This is especially important in black and white photography, as water can often just look dark and lacking detail. Place the camera on a tripod and set the shutter to a slow speed. This will give a feeling of movement in the water, as it will come out blurred. If you include people, place them in the foreground so they can be clearly identified.

Exposure can be a potential problem when photographing water. If you are on the beach, where the sand and sea are both highly reflective, it is easy for the camera's metering system to think that there is more light than there actually is, leading to underexposure.

Water often looks at its best first thing in the morning or early in the evening. To capture the mirror-like surface of a lake, you will need to be in position before the sun has risen. It is amazing how, as the sun gets higher in the sky, the water begins to ripple and the mirror-like effect disappears. Shooting against the light (see pages 46–49) can be very effective when photographing water. You will need to take a meter reading from the highlights to prevent overexposure.

Right: These rocks form an interesting middle ground for this seascape picture and the sheen of the incoming tide adds further tonal interest. I used a 300mm telephoto lens to tighten up the overall composition.

Opposite: This tranquil view of a canal in Venice is perfectly composed using the rule of thirds, or the principal of the Golden Section. The canal occupies one third of the picture, while the buildings on the left occupy another third. The remaining area, the sky, forms a perfect backdrop.

Below: Even though this was shot with an overcast sky, the steam from the hot springs in Yellowstone National Park gives the foreground interest. The black tone of the trees adds to the bleakness of the environment.

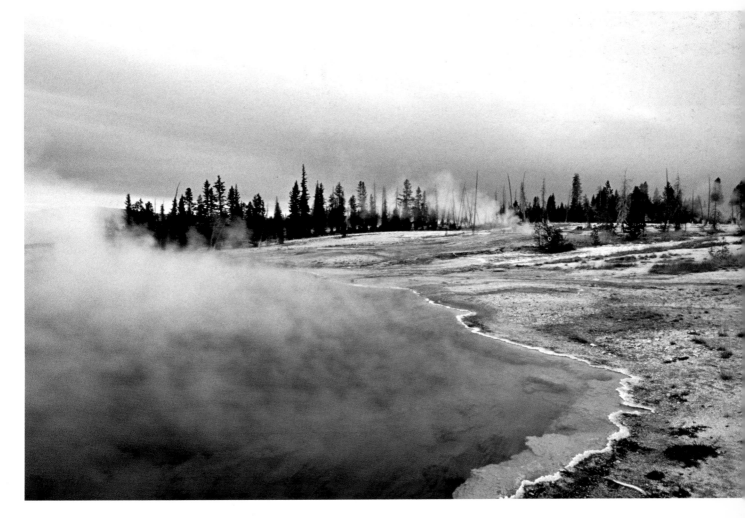

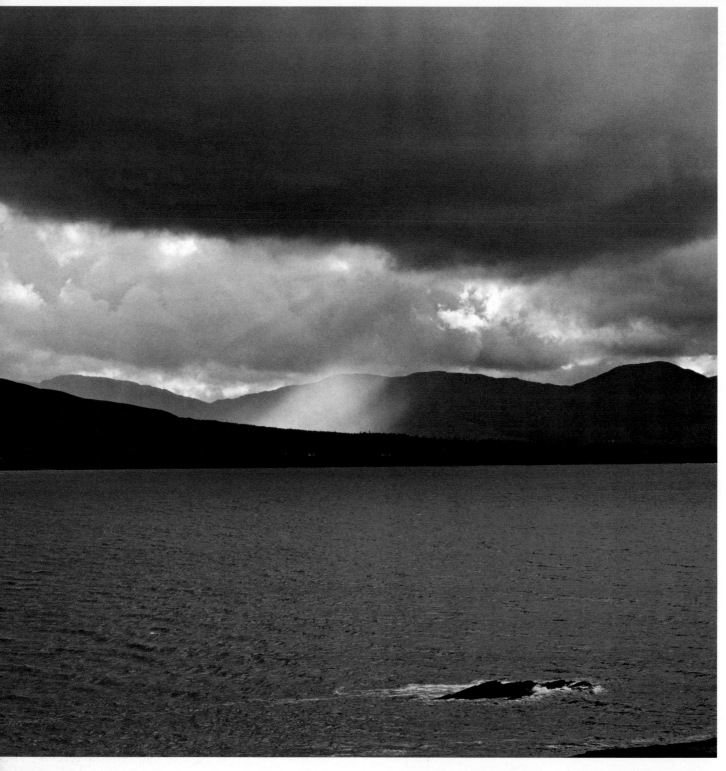

Above: Even when the weather is overcast, it is still possible to get interesting pictures. In this shot the rays of the sun's light, breaking through an opening in the clouds, forms an interesting detail on the hills in the background.

Opposite: In contrast, this early morning shot was taken in clear, bright sun. The clouds reflect well in the lake and the rough terrain gives interest to the foreground. Early mornings are the best times to get good pictures of lakes and other stretches of water.

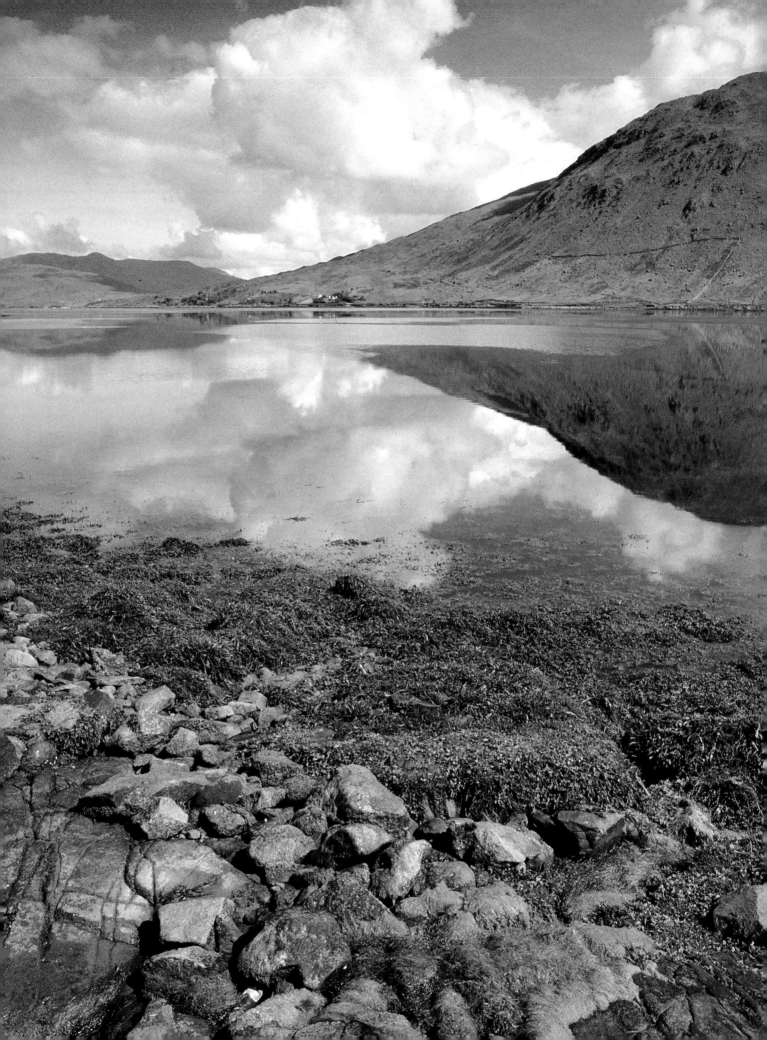

Emphasising the Sky

Whether it is strong cloud formations of a stormy sky, a dramatic sunset, where the clouds are fringed by the dying sun, or a blue sky with white, cotton wool clouds, skies can make or break a landscape photograph. The problem that many photographers have is getting the exposure correct. All too often, either the sky comes out overexposed so that the clouds have virtually disappeared, or the foreground is so underexposed that it is impossible to see any detail there either and all the drama of the scene is lost.

The reason for this difficulty is that the exposure required for the sky can be several stops different from that needed for the foreground. The most effective way to correct this imbalance is to use a graduated neutral density filter (see pages 122-125). This will help to even out the exposure of the sky and the foreground by cutting down on the amount of light entering the lens from the sky portion of the picture. These filters come in different densities and can be doubled up for a really dramatic effect. As with so many accessories, the type of camera they work best with is the SLR. The reason for this is that you can see the effect that the filter is having as you look through the viewfinder. This means that you can get it into the precise position for the most effective result.

Always be on the look out for different lighting conditions, which can occur quite suddenly and totally alter the feel of a landscape photograph, making the difference between an ordinary view and a spectacular one. An example of this kind of situation is where dark, almost black, storm clouds appear as the backdrop, while the sun still shines brightly on the foreground. To capture this type of effect requires fast reactions as such conditions can change rapidly.

Shooting into the light and exposing for the highlights is another way of emphasising the sky. This method can add drama, especially if there is an expanse of water in the foreground. A low viewpoint and a wide-angle lens will also increase the dominance of the sky.

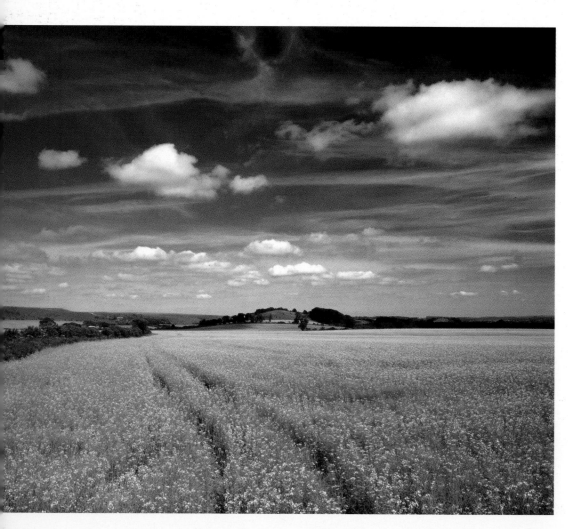

Left: To retain the detail in this sky I used a polarising filter. In colour it would have had the effect of deepening the hue of the blue, making the clouds stand out with greater clarity. In black and white photography, it turns a blue sky darker, giving the clouds greater prominence.

Opposite: In this shot I exposed for the highlights. This has meant that the detail of the sky and the highlights on the water have been retained. However, everything else has come out underexposed, creating a low-key image.

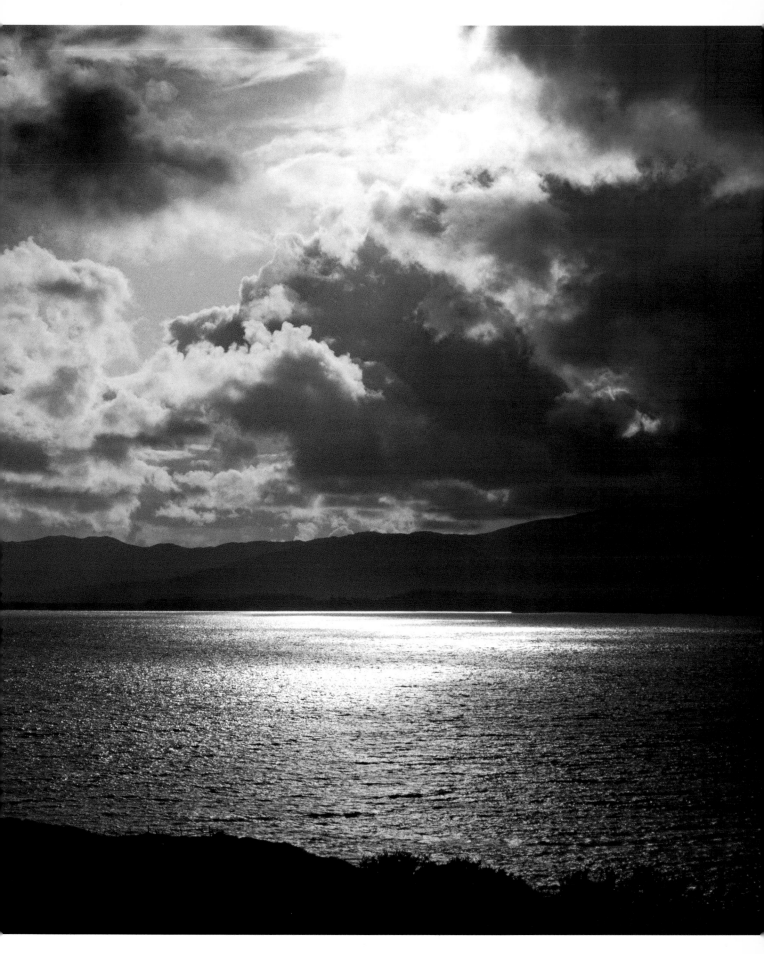

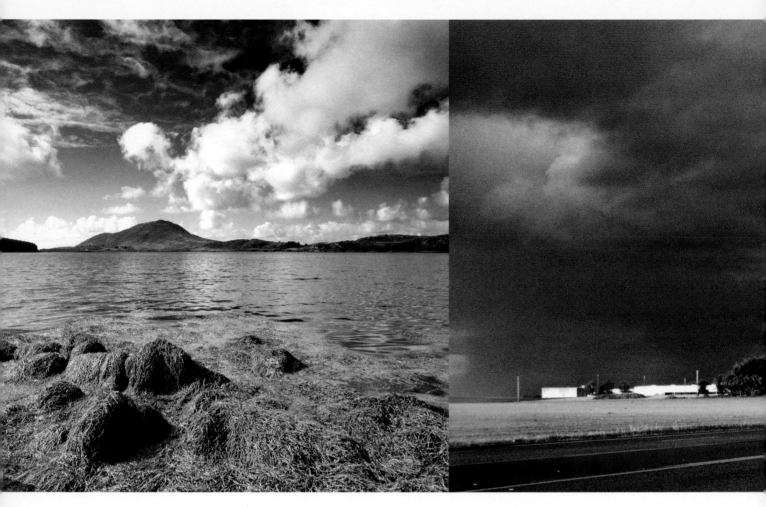

Above left: Instead of using a polarising filter, I used a graduated neutral density filter to keep the detail of the sky in this picture. A low angle has helped to emphasise the clouds, which appear to billow overhead.

Above right: I had to react quickly to get this shot of an oncoming storm. The sun was shining brightly on the foreground, while the sky was turning as black as coal. Minutes later the light had completely disappeared and all contrast had been lost.

Opposite: This was a similar situation where the sky was dark but the buildings were lit up by the sun. Exposing for the buildings has helped to retain the moodiness of the sky, emphasising the dark, ominous appearance of the clouds.

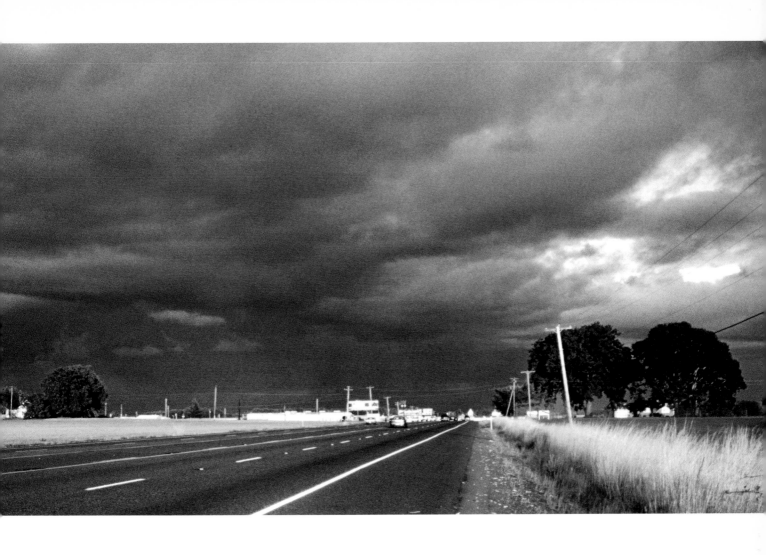

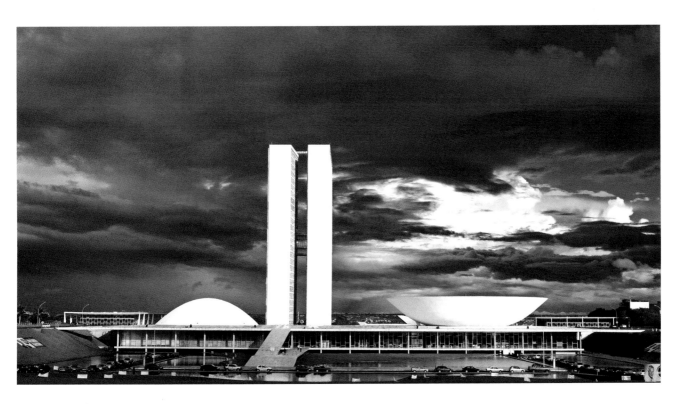

Architecture

As buildings are permanent fixtures, the observant photographer has the advantage of seeing them at different times of day and night, in varying lighting conditions and through every season. It is through awareness of the effect of these changes that we can start to see ways of photographing different types of architecture under the best possible circumstances.

With many buildings, especially modern skyscrapers, the tendency is to point the camera upwards. It is understandable, as this is usually the only way we can get the whole building into our shot, but it always results in what is known as converging verticals. This means that the building appears to taper towards the top. While this can look dramatic and be used to creative effect, some buildings, for example a cathedral, can look distorted.

There are two ways of rectifying converging verticals, either by using a perspective control lens, or correcting the perspective in Photoshop. PC lenses are sometimes referred to as shift lenses. With this lens, providing the film or sensor plane is kept parallel to the subject plane, then all uprights will remain vertical. With a normal lens, setting up the camera in this position would result in the top of the building being cropped out. By adjusting the shift of the PC lens, the top of the building can be brought into view without having to tilt the camera upwards. As they are specialist, these lenses are expensive to buy, but can be hired quite easily.

Modern buildings are well suited to black and white photography because their surfaces of bright metal and glass provide good contrast and strong geometrical shapes, with colour really an irrelevence. Also, many modern buildings carry their services on the outside. These shapes, made up of pipes and ducts, high tension cables and ventilators, are perfect for going in close, either physically or with a telephoto lens. Because of the graphic nature of much modern architecture, the subject lends itself to high contrast printing (see pages 150–153) to create abstract images.

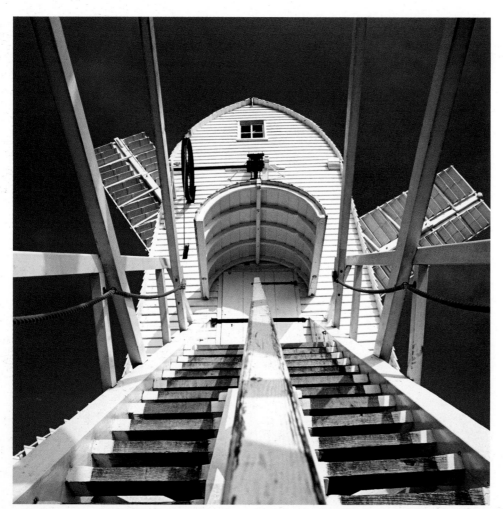

Left: This is a view of the rear of a windmill and I felt that the timber structure made a strong geometrical composition with an almost symmetrical quality. I used a 50mm standard lens and stopped down to f16 for maximum depth of field.

Opposite: The metal and glass materials used in this structure create a building that wears its modernity with panache. Buildings like this are highly reflective and present the photographer with endless possibilities for creating abstract imagery.

Above: I chose dusk to photograph this suspension bridge and its three separate spans. It reflects well in the water and there is enough detail in the sky to give it interest. If I had waited till later, the sky would have been a bland backdrop, devoid of any detail.

Opposite top: This highly reflective building looked better in daylight and I framed it so that the ferris wheel – which is not part of the structure – appeared at the far end. It continues the theme of curves and makes the shot look as though it is a picture of a giant machine.

Opposite below: Often it is the details of buildings that make for interesting images. These are the ventilation shafts of a modern London office block, which look like futuristic buildings in their own right.

Above: So that this shot did not suffer from converging verticals, I used a PC lens. This type of lens is invaluable for architectural photography but can also be used for many other applications.

Interiors

The biggest problem when photographing interiors is the light, or more accurately the lack of it. Many of us will have attempted to photograph the inside of a building that we have visited on holiday, only to be disappointed with the result. Usually this is because the picture comes out underexposed, with all the grandeur and detail lost in the darkness. If your camera has built-in flash, it will be totally inadequate to light the interior of even the most modest church, let alone St. Paul's Cathedral! For this reason it will be best to use the available light and a long exposure, so a tripod and cable release will be essential.

As with photographing exteriors (see pages 88–91), converging verticals can be a problem. If you do not have specialist equipment, try to find a high viewpoint for your shot, such as a gallery or staircase. This will enable you to include more of the interior and keep the camera level. Be careful when using a wide-angle lens. This can "stretch" the shot, making it look as though it were taken through the wrong end of a

telescope, leaving the background detail lost in the distance. Nevertheless, such a lens does have its uses, especially if want to look up to show as much of the ceiling as possible. A fisheye lens is particularly effective in this situation.

Once you have selected your viewpoint and lens, consider the type and amount of light that is available. Ask yourself if the scene is well lit with daylight from side windows or from an atrium above, or is it artificial light from spotlights or chandeliers? If you are taking your shot looking down a church nave, with windows on each side, it is unlikely that the daylight will be coming evenly through all the windows. This means that one side of the interior would be in deep shadow, while the other could be bathed in strong daylight. Your only remedy here is to fill in the shadow area with multiple flash, or wait until midday to see if the light is more even. If the light is bright but hazy, then the interior of the building should be evenly lit. As you are shooting in black and white, you will not have to worry about the colour balance of the different light sources.

Opposite top: Increasingly, modern buildings like to show off as much of their construction materials or service pipes and ducts as possible. Looking up to the ceiling gave me the opportunity to shoot the intricacies of this construction.

Opposite below: Continuing with that theme, I shot this church ceiling looking straight up. The angel was suspended by wire but looks as though she is ascending heavenwards.

Left: I needed to increase the ISO for this shot to 1250. This has increased the noise – the digital equivalent of grain – but I felt that it added to grittiness of the interior. The use of a wide-angle lens has increased the feeling that the tunnel goes on forever.

Above: This is a shot of the interior of the dome of St Paul's Cathedral in London. I needed to mount the camera on a tripod and made sure that it was level in all directions by using a small spirit level.

Opposite above: Although fisheye lenses, with their 180° angle of view, have limited uses, I felt that in this particular shot of a church interior it was appropriate. Even at the edges of the frame, the distortion is within the bounds of acceptability.

Opposite below: Sometimes it is the simple approach that is the most effective. This interior of a room in an ancient Irish castle is bathed in natural light and has a monastic quality to it.

Documentary

Documentary photography is a way of telling a story through a selection of pictures. Although they could be accompanied with text, it will be the pictures that attract the readers. It can be applicable to any theme, but in black and white photography it is normally associated with war, social or environmental issues that have been shot in a gritty way.

Another way of describing this type of photography is photo reportage. The essence of this style is to convey as much, varied information as possible in just a few images. Historically, there is a long line of great documentary photographers like Walker Evans, Eve Arnold, Bill Brandt and Don McCullin, whose powerful images featured in magazines like Life, Picture Post and Paris Match, to name a few.

Although you might not have the benefit of time to research a particular story, it will pay to write down the essential elements of what you are going to photograph, both to focus the mind and to equip yourself properly. For example, if your story includes people, then strong portraits of interesting faces will be on your list. This will require a telephoto lens in the range of 100mm to enable you to get in close and fill the frame. A longer lens will enable you to take candid shots as well as bringing distant objects closer.

As documentary photographs are most likely to be shot in available light, it is sensible to use a fast film or increase the ISO on your digital camera. Even if you start in quite bright conditions, you don't want to waste time reloading films or fiddling with the ISO dial if a shot presents itself in less favourable light. It is the ability to work quickly but produce striking, well-exposed shots that is the hallmark of a great reportage photographer.

Another, personal, quality that is essential to this style of photography is diplomacy. Although you might be desperate to get your shots, sticking your camera in certain people's faces, without gaining their confidence or respect first, could result in them turning the tables on you - with more agressive intent.

These pages: I shot this picture series in a favela in Rio de Janeiro, Brazil and I wanted to concentrate as much as possible on the people. Whenever I am in a situation like this, I always get into conversation with the person or people that I want to shoot. This helps them to have confidence in me and breaks down any inhibitions that they might have. It also means that, more often than not, I get invited into areas or places that I probably wouldn't go if I was on my own because it would be too dangerous – especially with very expensive kit in my bag.

These pages: This environment couldn't be more different to that of the previous pages, but the approach is much the same: I wanted to get across the key elements of this busy Michelin-starred restaurant. This is not the type of place to get in the way of the chefs as they prepare elaborate dishes for many diners. I liked the concentration portrayed by the head chef as he arranges one of the dishes. I set the camera to 400 ISO and took all the shots in available light.

Animals

There is a famous saying in showbusiness that states: "never work with children or animals", but as photographers, we know that both can make delightful and rewarding pictures. There are great similarities in photographing these two subjects – they don't like being told what to do and they definitely have their own ideas! So be alert and prepared for unexpected opportunities.

By now, we all know the benefits of carrying a camera at all times, and this includes everyday tasks such as walking the dog. A good pet portrait is often the simplest one, such as a photograph of the dog observing its own surroundings or meeting a new friend in the park. Cats, being more independent, can be a little trickier to photograph. It is possible to catch them on the prowl, intently waiting to pounce on their carefully chosen quarry, but probably easier to shoot them when they are in a resting position. Because you need to act quickly, shooting digitally can sometimes be problematic. The reason for this is that, with some cameras, there is a delay in the shutter firing after the button has been pressed. As the technology improves, this problem will be overcome and, with cameras higher up the price range, it has already been virtually eliminated.

Now that travel to wild and exotic places is more accessible, the chance to photograph animals in their natural habitat has never been greater. But even close to home, there are many opportunities for photographing wildlife. Almost every region has a living eco system that supports wildlife and it is a matter of simple detective work to discover where to find it. Even cities in highly developed countries now support a growing population of foxes as their natural, rural hunting grounds become built-up. Zoos can provide good pictures, but even better are safari parks, which try to provide an environment that is reasonably free and natural for the animals.

A telephoto lens of at least 200mm will be essential to get in close enough for decent shots of wild animals. A 400mm would be better still. If you do not have one of these, a 2x converter will be a good alternative (see pages 14-15).

Left: A good telephoto lens is virtually essential when photographing wildlife as often it is not possible – or wise – to get close. I would suggest that the minimum focal length would be 200mm and, if you combine this with a 2x converter, most situations should be within your reach. Anything longer than this will probably be prohibitive on cost grounds, unless you are going to specialise in this type of photography.

Above: Patience is essential when photographing wildlife, as well as a certain amount of agility. I crawled on my stomach for about half an hour to get close to this baby penguin, which had got separated from its mother.

Opposite: It is not always necessary to travel to an exotic corner of the world to shoot wildlife. This shot was taken in a safari park from a car window. I used a 400mm telephoto lens with a shutter of 1/1000th second and an aperture of f5.6.

Above: While not thought of as exotic as wild animals, the domestic variety can still provide good opportunities for photography. The advantage is being able to get in close, as you will be familiar to the animal, so there will be no need for long telephoto lenses.

Left: Probably the easiest of all animals to photograph is the domestic cat, if only because it seems to spend most of its life sleeping. Even in this state, it can provide the photographer with endless opportunities.

Opposite: Not all shots of animals need to be taken outdoors. I took this in a studio, using flash. I got the dog to sit in front of a black background and I positioned two flash heads slightly behind the dog and pointing towards him. I then placed two reflectors either side of the camera, to bounce light back onto him.

Still Life

One of the great advantages of photographing a still life is that it can give you complete control over the lighting and viewpoint. Also, if you are shooting indoors, there is no need to worry about the changing light, the time of day, or the weather. There is no need for a huge array of lights and elaborate tables and supports either. In fact, many effective still life images can be shot with just a single light source on the kitchen or dining room table. As you are shooting in black and white, it is essential to choose objects that are strong in contrast and/or texture.

When setting up a still life, give yourself as much flexibility as possible. Using a table allows you scope to shoot from above, straight on, or looking up. These options are important as the camera's viewpoint can dramatically affect the overall appearance of the photograph. The same is true of lighting. To be able to move your light source to the side, behind or below your subject, will give an unparalleled degree of creative control.

If you are using an SLR camera, consider buying a close-up device. This could be extension bellows or extension tubes. These fit between the camera body and lens and enable you to focus closer on the subject but, used with a medium telephoto lens, you will not have to move the camera physically closer. This is important as you might want to set up a reflector or flag between the camera and the subject. A telephoto lens will also give less depth of field, which might be an advantage if you want the background to fall out of focus, or if you only want a small area of your subject to be sharp. A rigid tripod with adjustable legs and a pan-tilt head will be an asset.

Consider the type of light your chosen source will deliver. Whether it is electronic flash or tungsten, the reflector or dish will determine the harshness and spread of the illumination. For example, a dish with a white surface will deliver a light that is softer than one with a silver surface. A diffuser over the dish will have a similar effect, whereas a honeycomb fixed over the front of the light will make it more directional and crisp.

Above: Shooting candles requires a slow shutter speed. I shot these at 1/4 second at f8. You need to be aware of any ambient light because this could over expose your shot and kill the atmosphere of the candle's flame.

Opposite: Shooting still lifes in black and white can be tricky if the tones are all of a similar nature. Here there is a good range of textures and tones and the arrangement has been carefully considered to produce an effective still life.

Above left: Still life does not have to be complex. Although this is a very simple arrangement, it has a pleasing quality to it. The light is soft yet directional and coming from the left of the frame. This helps to bring out the texture of the pots and, more importantly, the wall in the background.

Above right: I shot these egg cups using a wide aperture of f3.5. This has kept the depth of field to a minimum and, by focusing on the top edge of the egg cup, the effect is almost abstract. I used mirrors to reflect light back into the steel to create small highlights.

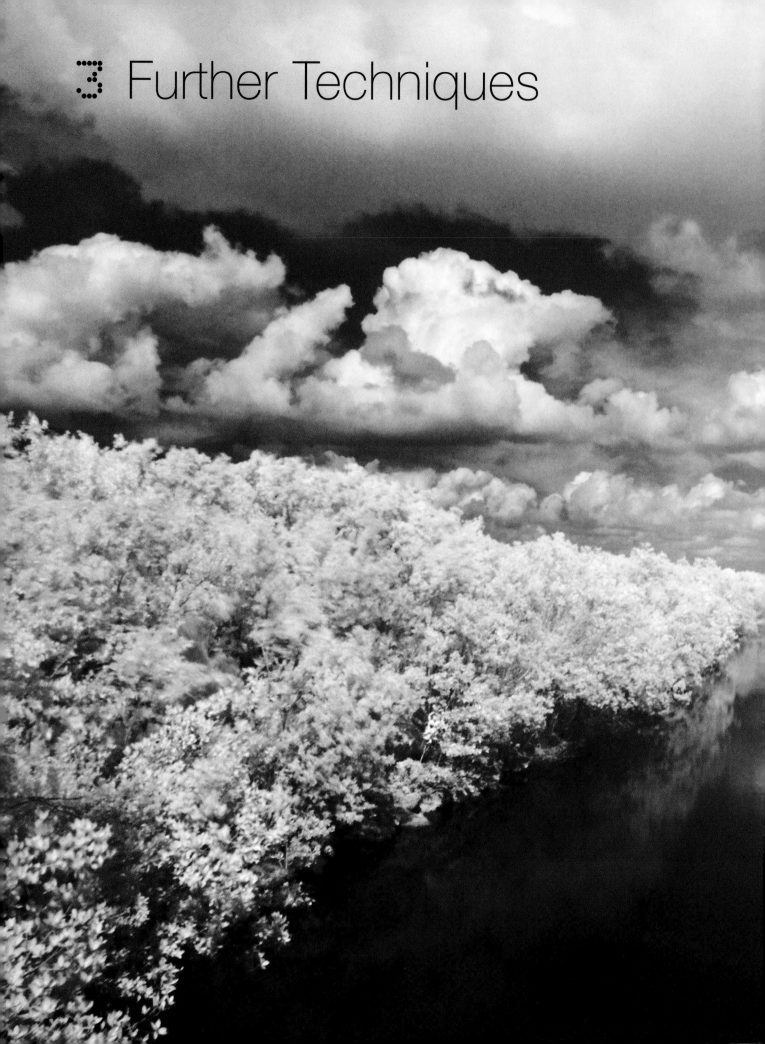

3 Further Techniques

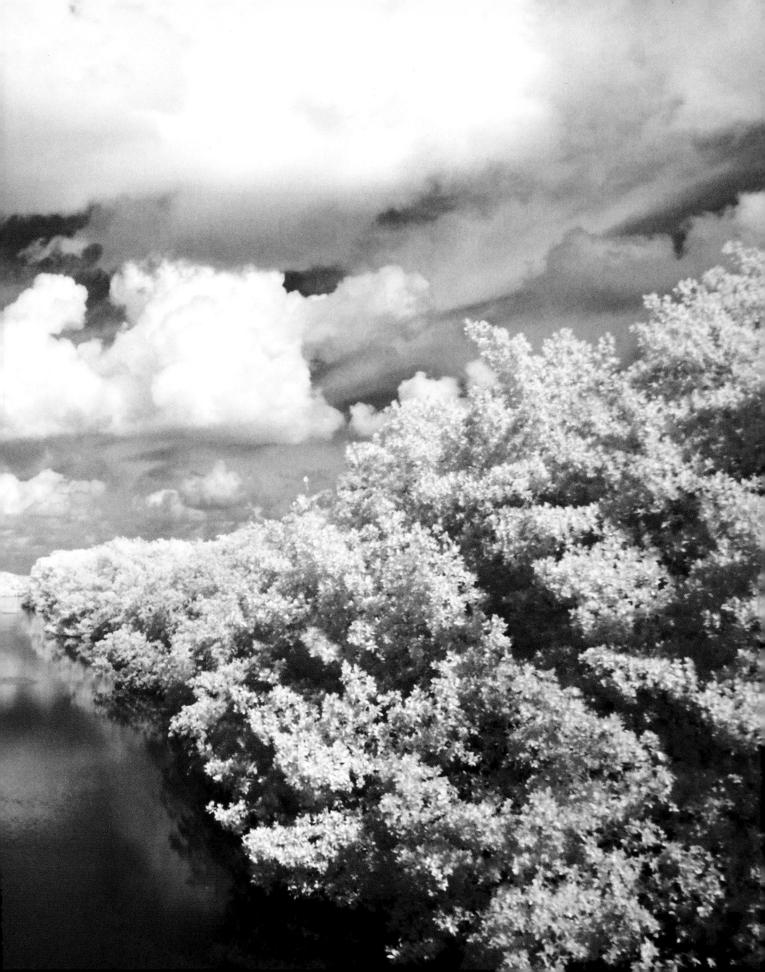

Multiple Images

There are several different ways of producing multiple image photographs and they can be particularly well suited to black and white photography. The two most common methods are either to shoot a multiple exposure picture in camera, or to create it on the computer. If you are going to shoot the former, forethought is essential, as you need to plan carefully, deciding exactly where you want each constituent part to be. If you have a camera that allows you to change the focusing screen, you might find it helpful to fit a grid screen, which has vertical and horizontal lines running across it. It can be a great help in composing a photograph like this as you will know exactly where to put each shot as you take it.

Of course, your multiple image photograph might be taken from the same spot with the camera mounted on a tripod. Many SLR cameras have a multiple exposure facility that enables you to do this quite simply. The purpose could be to build up movement in the sky, for instance. If your exposure

under normal circumstances would be, say, 1/15th sec at f22, you could take six separate exposures at 1/500th at f22. If you take these six shots at intervals, any cloud movement will be blurred. For the greatest effect, all other detail must be completely still, so a tripod and cable release are essential.

Another way of creating a multiple landscape image is to use a single photograph that you have downloaded or scanned onto the computer. From this starting point, you could make a duplicate version and then flip it to make a mirror image. Having done this, both images can be butted up to one another and then printed. Careful selection of the original shot is vital for the finished print to have maximum impact, you may need to experiment to see what works best. Of course, one doesn't have to stop with just two versions. Any number of original and mirror images can be treated in this way to build up the effect. To increase the abstract quality, you might want to tone the image, or make a high contrast version (see pages 150–153), which will give the finished print an extremely striking quality.

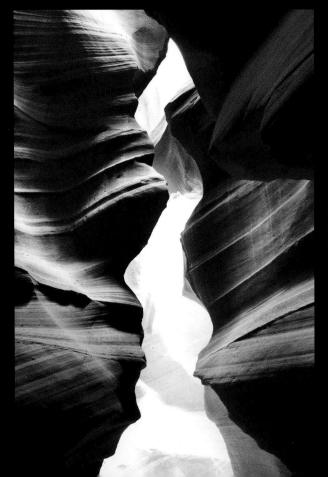

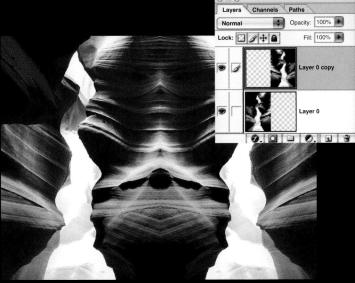

Left: I thought that this shot would make a good basis for a multiple image print. I very much liked the tones and shapes that the rock face provided and thought that, by duplicating it and then putting the two together, it might make an unusual multiple image.

Above: Having made the duplicate image onto a layer, I then doubled the canvas size. I then flipped and joined the two images together and examined the shape that the multiple image now made.

Above: I created this sky effect in camera by building up the exposure over several shots. To do this effectively you need to have the camera on a tripod, otherwise the picture will just be blurred. The exposure required was 1/15th at f22. However, I set the multiple image setting on the camera and took eight separate exposures of 1/125th at f22. Each time I took a shot to build up the exposure, the clouds had moved slightly. By the time the final shot had been taken, the clouds looked as though they were moving across the sky. This technique is applicable to both film and digital.

Above left: I then enlarged the centre portion of the new image and rotated it 180°. However, I thought that it still did not look quite right.

Above centre: I rotated the image another 180° but still retained the original centre portion. I studied this but was still not satisfied.

Above right: I then took the original image and reversed it the other way and used just one side. Although I thought that I was now getting the sculptural shapes I was after, I still felt I could do more.

Overleaf: I now had an image that was more to my liking and I adjusted the tones in Channel Mixer. The final image looked striking, with the rocks resembling interlocking elements, like a jigsaw.

Digital Composites

Many photographers have had the experience of seeing a potentially good shot ruined because the weather was dull and overcast, or the background was inappropriate for the subject. Today many shots that have suffered from faults of this type can be revitalized with Photoshop.

The first thing to consider when creating digital composites is that the two or more shots you are going to combine must compliment one another. This means that if you are going to replace the sky in a landscape shot, you need to replace it with one that has been taken from a realistic, believable angle. You also need to choose one that has a similar tonal range. For instance, if you choose a sky from one picture taken from a low viewpoint and use it with a landscape shot from a higher viewpoint, the perspective will look all wrong. Similarly, if you choose a shot with a bright, sunny sky and combine it with a landscape that has very little shadow detail, the finished picture cannot appear very realistic. However, new life can be given to mediocre pictures by using the right images.

Even in countries where the weather is generally favourable, skies can be flat and uninteresting due to heat haze or pollution. With this in mind, it is important not to give up on a shot just because one of the elements, such as the sky, is not how you really want it. Try to envisage it with an element of a shot that you have in your library already, or can shoot specifially.

Besides joining two or more pictures together to enhance an existing image, it is possible to create a composite from scratch. There are many instances where this could be applicable: in the example on these pages, I wanted to photograph the parents with their daughter. They all used to live in Rio, but the parents had now moved far away. Having already shot a panorama of the city, I shot the group at the parents' home. It was important that the two images had similar tonal values and that the lighting appeared balanced in them both so that they blended seamlessly together. By creating the composite, the family has a reminder of how they used to be together in that great city.

Creating a composite image

I chose a view of Rio with its distinctive Sugarloaf as the background to the digital composite that I had in mind. I then chose the family portrait that I wanted to combine it with.

Step 1: I cut out the three family members from the background using the Extract tool from the Filter Gallery.

2

3

Step 2: I then moved the figures into position using the Move tool from the toolbar.

Step 3: Because the background was dark, I lost some hair detail. Choosing a small brush, I painted hair in where it had been lost in extraction.

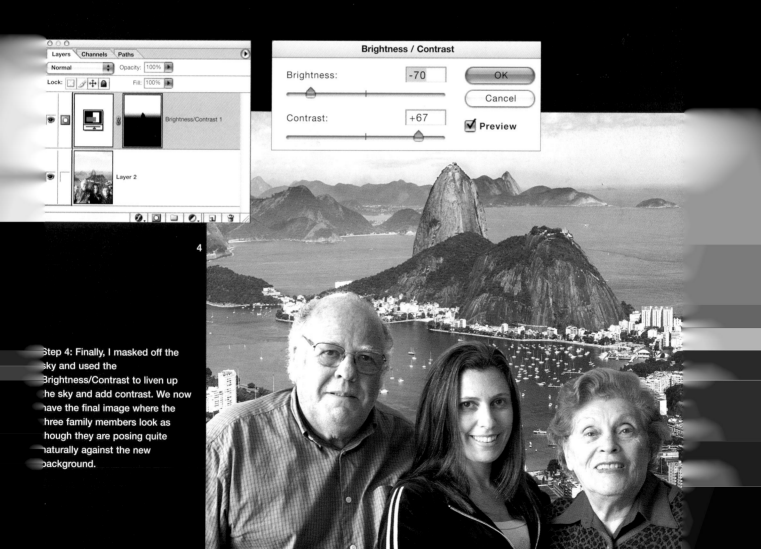

Layers Channels Paths

Normal Opacity: 100%

Lock: Fill: 100%

Brightness/Contrast 1

Layer 2

Brightness / Contrast

Brightness: -70 OK

Cancel

Contrast: +67 ☑ Preview

4

Step 4: Finally, I masked off the sky and used the Brightness/Contrast to liven up the sky and add contrast. We now have the final image where the three family members look as though they are posing quite naturally against the new background.

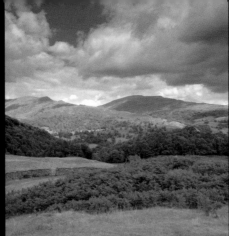

Improving an existing image

I thought that this landscape, which I shot in Ireland, would have looked better if the sky had not been so flat. I decided that I would composite the sky from another image, which was shot in England. It is important that the image that you choose will have clouds that blend in with the landscape and have a similar tonal range.

Step 1: Using the Magic Wand tool, it was easy to remove the large expanse of sky from the image that was to be transformed.

Step 2: For the replacement sky I chose a shot from my library and introduced the sky on a layer behind the first picture.

Step 3: Using the Move tool I positioned the sky in exactly the position that I wanted it.

Step 4: I neatly cut out the background using the Eraser tool.

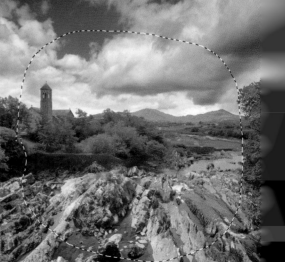

Step 5: Using the Lasso tool, I roughly highlighted the centre of the image. I then chose Select > Inverse and feathered the selection to blend it in. With Curves, I darkened the sky and enhanced the edges of the picture.

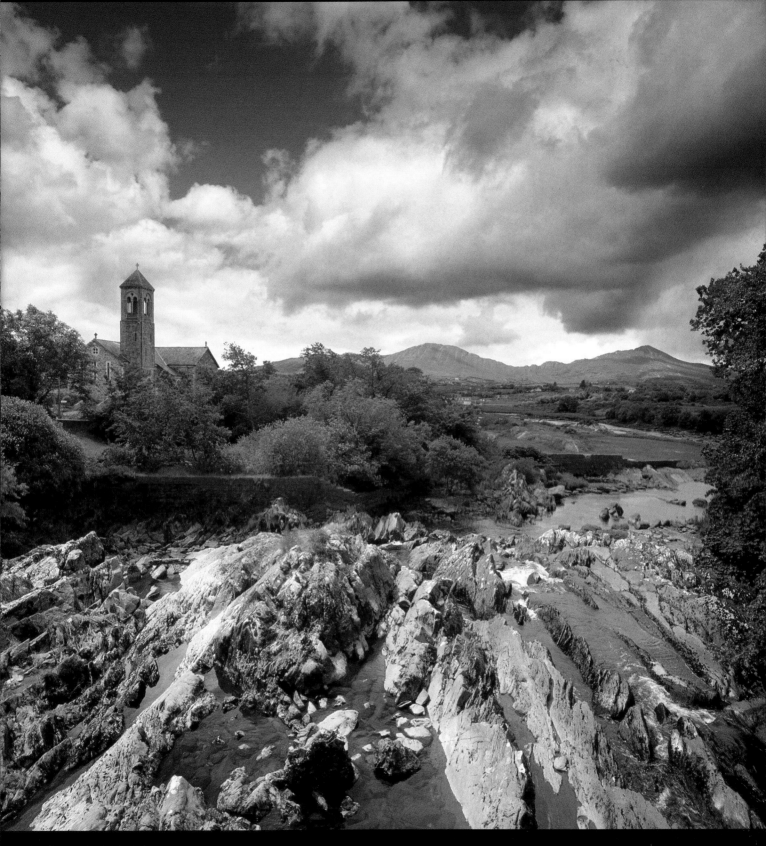

Above: The finished picture,
looking far more dramatic than
the original and having a good
tonal range throughout.

Black and White from Colour

Of course, the best way to create black and white photographs is to shoot on the appropriate medium to begin with. However, if you find yourself in a situation where you only have colour film, or that your digital camera does not have a black and white mode, you will have to convert the image at a later stage. If you have shot on film, this could be done by making an inter-negative. This is when the negative or transparency is re-photographed on the appropriate black and white stock. However, this technique has been virtually superseded by scanning the image into the computer and out-putting black and white prints.

There are several ways that you can produce black and white prints on a computer, and the simplest is to go to Image > Adjustments > Desaturate. While this will give you an idea of what the image will look like in black and white, it is a particularly crude method and the chances are that the image will look flat, especially in the highlights and shadows.

A far better method is to use Channel Mixer, found by going to Image> Adjustments > Channel Mixer. Another advantage of this process is that it is not "destructive", unlike using Lab Mode or Greyscale, both of which permanently change the digital file. When the window appears, tick the Monochrome box, which is found in the bottom left, and this will convert the image to black and white. You can now use the three channels, red, green and blue, to adjust the tones of the image. In the wet darkroom, different developers and grades of paper - soft, grade 1 or hard, grade 5 - were selected to obtain the tonal range that best suited the image. You can think of the Channel Mixer in much the same way as these grades and apply them in varying degrees to obtain the best tonal range. Later, the Brightness/Contrast control in Adjustments can be used to further tweak the image. Certain areas can also be masked off to make them either brighter or flatter.

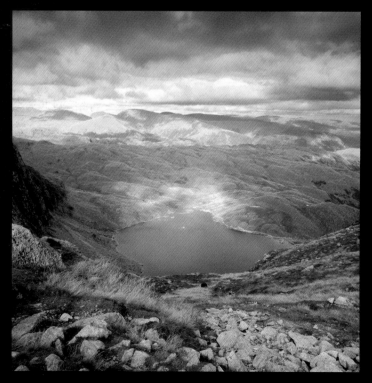

Converting a colour image

Sometimes, when looking through my library of colour images, it occurs to me that some might look better if they were converted to black and white. I decided that the shot on the left was just such an image so I experimented to see what it would look like in monochrome.

Left: I created a new Hue/Saturation layer to begin with and turned the colour off. I called this black and white. I then created another layer below the B & W one, turned that into colour mode and called it the filter layer.

By adjusting the filter layer, a variety of different tones can be created. Because the final choice is a subjective one, there are no hard or fast rules as to what the "correct" amount of Hue/ Saturation should be.

Below: Having adjusted the filter layer to my liking, I arrived at what I considered to be a superior image, with far more contrast and mood than the original colour shot.

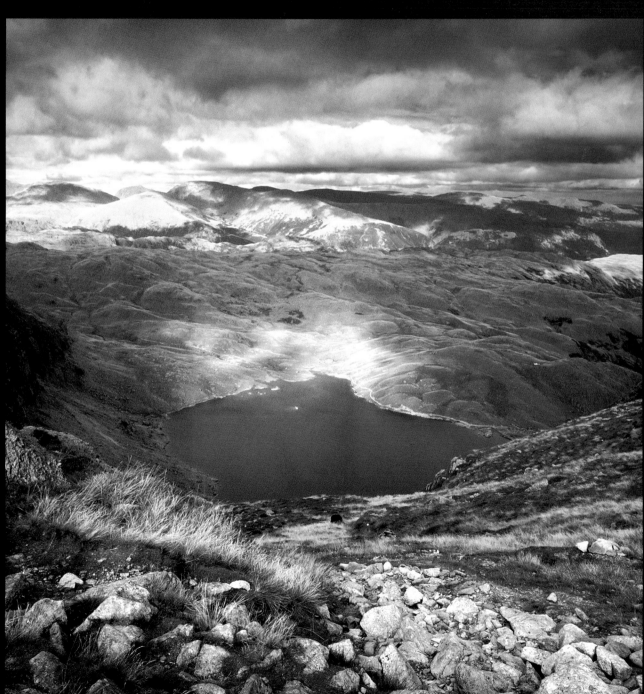

Making a duotone

Another way of turning a colour image into black and white is to make a duotone. As the name suggests, this is where you add another colour to supplement the black. This gives a great deal of control and, for certain subjects, the results can be very effective.

Above: To turn the image into black and white go to Image > Mode > Greyscale and discard the colour information.

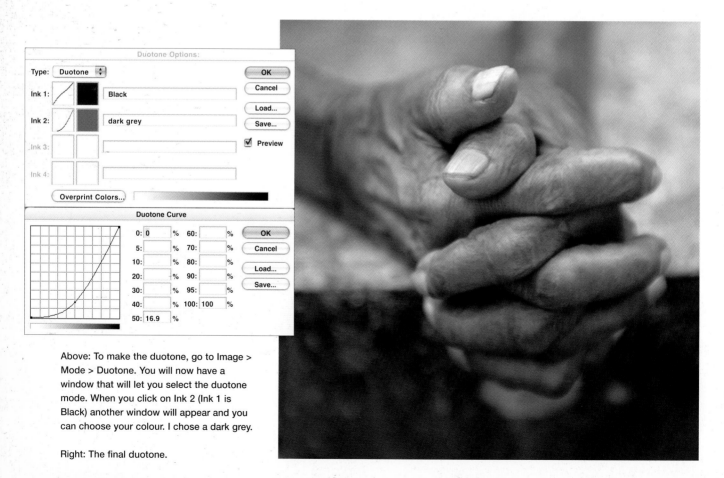

Above: To make the duotone, go to Image > Mode > Duotone. You will now have a window that will let you select the duotone mode. When you click on Ink 2 (Ink 1 is Black) another window will appear and you can choose your colour. I chose a dark grey.

Right: The final duotone.

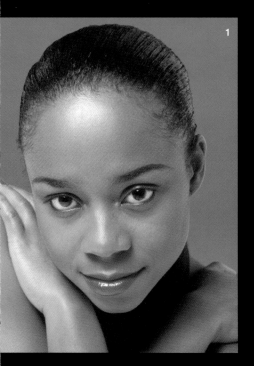

1

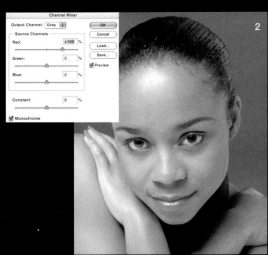

2

Step 2: The Output Channel will show Gray and the Red Source Channel will show Red at +100%.

3

Channel mixer

Another popular way of turning a colour picture into black and white is to use the Channel Mixer.

Step 1: To do this go to Image > Adjust > Channel Mixer and then click on Monochrome and then OK. This will have turned the image to black and white.

Step 3: We can then alter the Red Channel to 0% and adjust the Green Channel to 100%.

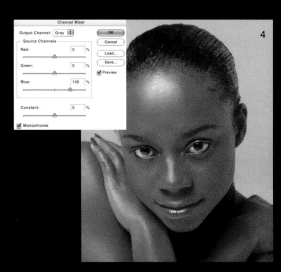

4

5

Step 4 (above): This is the effect when we adjust the Blue Channel.

Step 5 (right): The sum of the Channels should always add up to around 100% to maintain normal brightness. This was my final selection and the print now has a good range of tones.

Using Filters

There are several lens filters that are worth considering if you are shooting a lot of black and white. Probably the most common one is the yellow filter. These come in various strengths, with a No. 12 being the most popular, and will give your landscapes greater clarity in the sky. This is because they darken the blue of the sky, making the clouds stand out. A red filter, such as a No. 25, will darken a blue sky even further, sometimes looking like night-time. A green filter will lighten green foliage but darken red features, such as lips. When shooting black and white, the rule to remember is that a coloured filter will lighten a subject of the same colour and darken a colour that is complimentary.

A graduated neutral density filter is another very useful item for black and white, as well as colour. This, as its name implies, graduates from clear glass or plastic, to a band of what looks like a grey coating. This coating comes in various strengths and cuts down the amount of exposure required without causing a colour cast. This is excellent for photographing landscapes where the difference in exposure between the sky and the foreground would result in either the sky being burnt out or the foreground underexposed.

If you are using an SLR camera, it is easy to see what effect the filter is having and get it in exactly the right place. If you are using TTL metering, remember to set the metering mode to manual and take your reading before you slide the filter into position, or your shot will be overexposed.

Another important filter is the polarising filter. This serves two purposes, first to eliminate unwanted reflections and, second, to enhance a blue sky and make clouds stand out with greater clarity. To do this effectively, keep the sun at right angles to the camera when shooting and choose a time of day – usually mid morning – when it is at about 45°. With extreme wide-angle lenses the coverage of the polarising filter will only be partial. This means that one side of the frame will have a deep blue sky whereas the other will be unaffected.

Above left: When shooting in black and white – even digitally – there are a range of filters that we can use to enhance our shots. In this picture no filter was used and the tones are slightly flat.

Above centre: For this shot I used an orange filter and it has darkened the picture. Although you could replicate these filters on the computer, there is nothing like getting the shot correct at the time of shooting it.

Above right: By placing a green filter over the lens, the green of the foliage has become distinctly lighter. This is because, in black and white photography, a filter that is the same colour as the subject will lighten it, whereas a filter of its opposite, reddish, will darken it.

Opposite: For this picture of the Grand Canyon, I used a No 8 Yellow. This is a great filter for black and white landscape photography as it darkens blue skies, clouds and foliage.

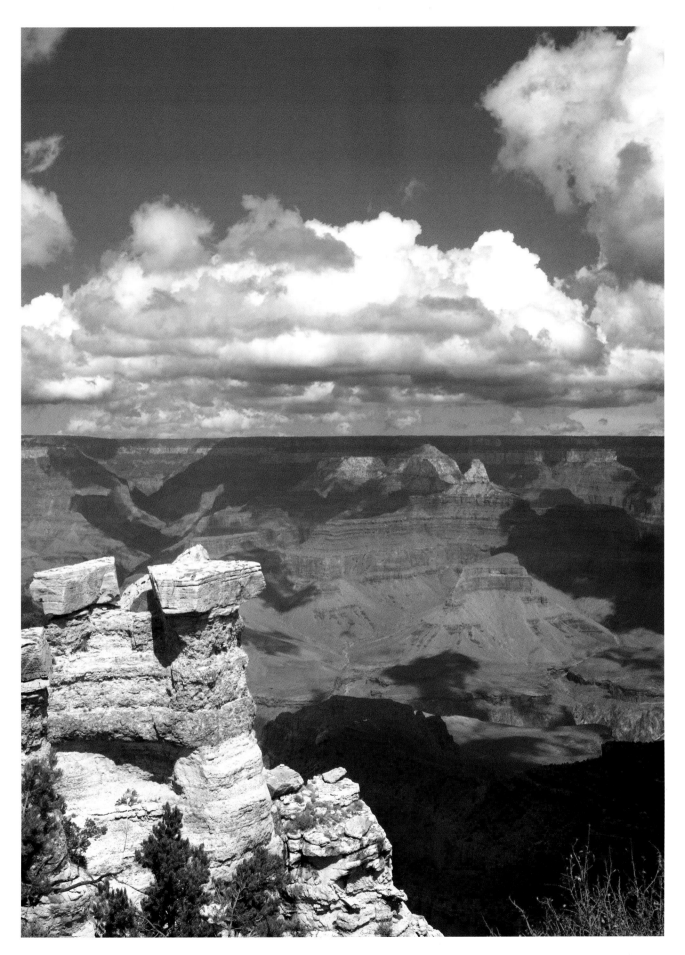

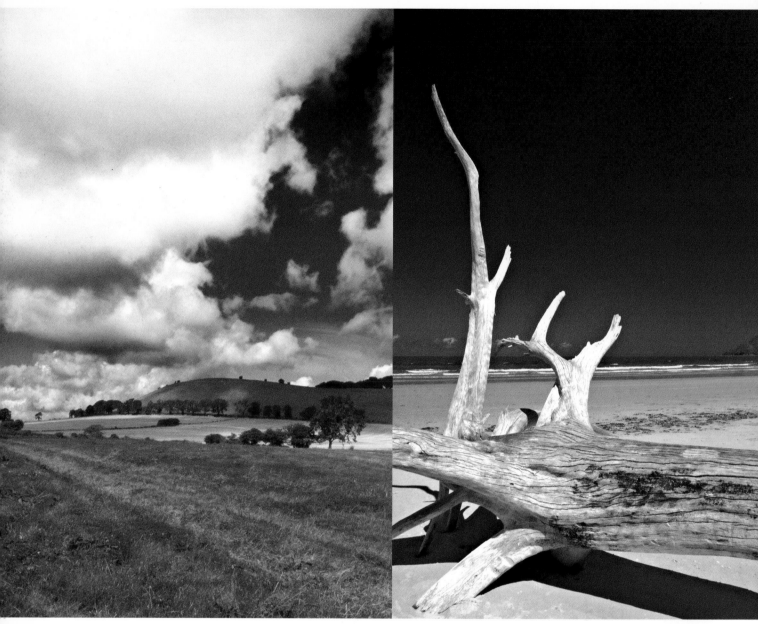

Above: To the naked eye, the clouds in this picture were billowing against the blue sky. However, when I took the shot on my digital camera without a filter, (right), they looked washed out. By using a polarising filter, the blue sky has darkened, making the clouds stand out. When converted to black and white, it needs very little contrasting up.

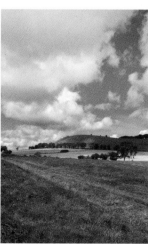

Above: For this shot I decided to use a No 25 red filter. This darkens blue considerably, and in some cases gives the appearance that your shot was taken at night. When using this filter, you will have to increase the required exposure by three stops. The effect is an almost surreal sky compared to the unfiltered shot, right.

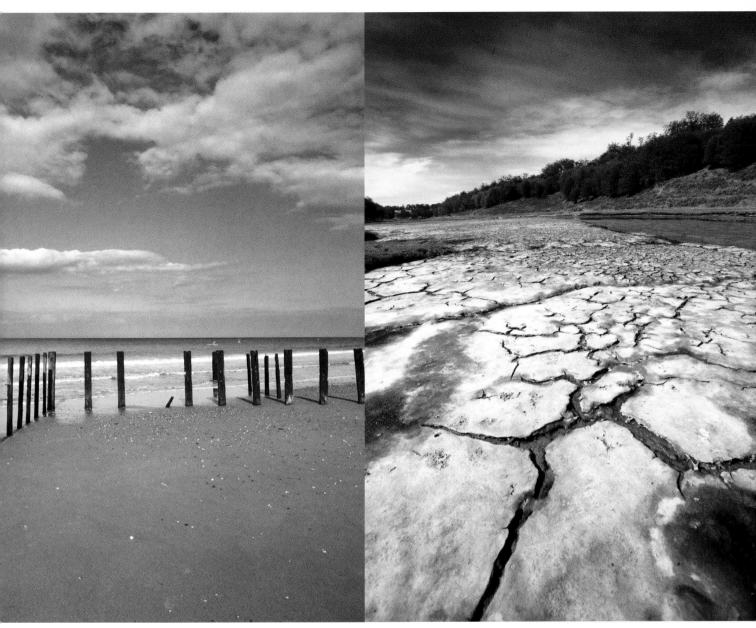

Above: It is always a good idea to carry a range of filters for black and white photography, even if you are shooting digitally. If you can get the effect you are after in camera, it will save many hours in front of the computer correcting the image. As can be seen in these two examples, the use of a No 15 yellow filter has had an enormous effect on the sky.

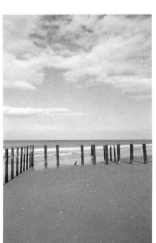

Above: Another useful filter is the graduated neutral density filter. This helps to balance the required exposure between the foreground and the sky. There is always a difference between these two areas and this filter cuts down the exposure required for the sky and brings it nearer to the exposure required for the foreground.

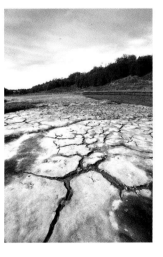

High-Key and Low-Key

High-key pictures are ones in which the tonal range of the print is primarily at the light end of the scale and should not to be confused with high contrasts prints, which have extremes of tones. Softness and delicacy are the essence of the high key look and a soft light is nearly always necessary to achieve it.

The easiest way to obtain this type of light is to use a softbox. This fits onto the flash head and, as its name implies, is a large pyramid-like box, black on the outside and lined on the inside with a reflective material, usually white or silver. The white-lined version gives a softer light than the silver, so it is well suited to the shot you are trying to achieve. Inside the softbox might be a baffle, in addition to the outer diffusing material that the light passes through. The more the light is filtered through this material, the softer it becomes, so once you have the light in position, you may decide to add more material.

Low-key pictures are the opposite - the tonal range of the print is at the dark end of the scale. Pictures produced in

this way can have a great cinematic or theatrical feel and look very dramatic. They are not to be confused with low contrast prints, which have a narrow range of tones and no definite black or pure white, usually due to underexposure, rather than a deliberate technique.

When shooting low-key pictures, black velvet gives a much richer black than standard photographic background paper because paper is slightly reflective, while the velvet absorbs light. When calculating the exposure for low-key lighting, take the reading from a highlighted area of the shot to prevent overexposure. You will probably need to use directional lighting, which may mean fitting a honeycomb grid over the light. Honeycombs come in a range of different meshes that range from fine to course. Each has a subtle effect on the quality of the light, so you need to experiment to find one that suits the style you are after. Once the honeycomb is fitted, there is very little spill, but you still might find it necessary to fit barn doors to the reflector, so you can flag the light to stop any straying.

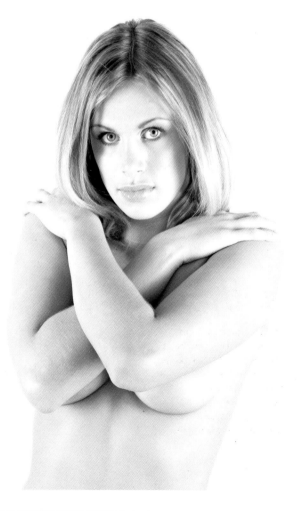

Opposite, far left: For this portrait, I used a satellite dish with a diffuser to create this soft high-key look. It was fixed to a boom and positioned slightly above the model's head and pointed down at an angle of about 45°. I then placed a white reflector at waist height to bounce light back up to her face.

Opposite, left: To photograph this young child, I posed him on a roll of white Colorama. This was suspended behind him and then run out along the floor to give a seamless background. Two lights were placed either side and slightly behind him to light the background and then one light was placed just to the right of the camera to light him. The result is a very light, high-key picture.

Above: I surrounded this rose on three sides with white reflectors and then positioned a softbox just above. I used a 100mm lens and fitted a No2 extension tube. This allowed me to get in close, while at the same time allowing enough space to be able to tweak the light and the reflectors.

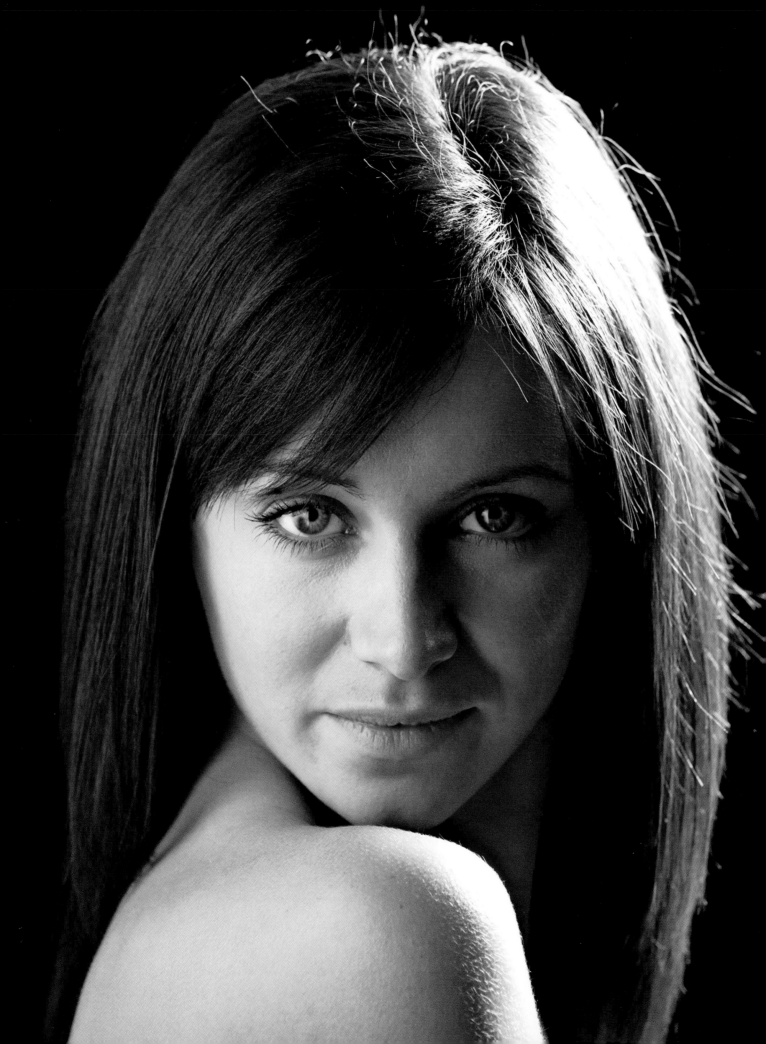

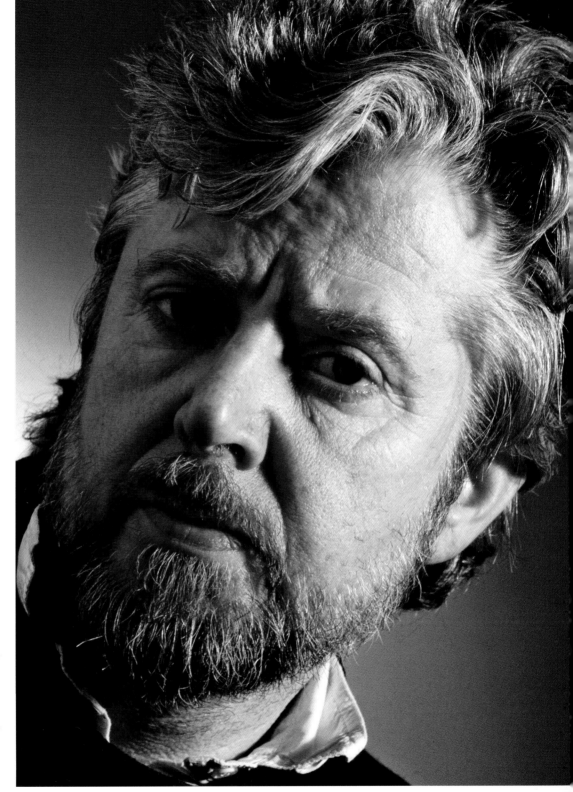

Right: To keep this portrait low-key, I used just one light on the face and positioned it at about a 60° angle. I placed a white reflector to his left and positioned it so it had just enough effect to lift the shadows. I then lit the background with another light, just to lift it from complete black.

Opposite: I used only one light for this shot, too. Here, I positioned it slightly behind, but pointing towards her. This created a nice, attractive pool of light in her hair but kept the side of her face quite dark. I then positioned a white reflector to her other side, which has given an even, soft light to that side of her face.

Infrared

Infrared photography has been popular with film enthusiasts for years, but not many people realise that it is possible to shoot black and white infrared pictures with digital cameras. With either medium, it takes a certain amount of experimentation to get good results, but the effort will certainly be worth it. It is most often used for lansdscapes, turning trees and other greenery a ghostly white and darkening skies to a dramatic level. The results can look very graphic in black and white, arguably, more effective than colour infrared, which can be a little gaudy.

One of the advantages that digital infrared photography has over film, is that you will be able to see the results instantly on the camera's LCD. With film you would have to wait for the processing and then re-shoot if you had either over or underexposed, which is quite an easy mistake to make with infrared. Not all digital cameras are capable of taking infrared pictures, however, and, ironically, it is the more recent models that have the problem. This is because most of them

manufactured today have a hot mirror filter between the lens and the sensor. The purpose of this is to screen out the wavelengths of the electromagnetic spectrum (measured in nanometers) that are sensitive to infrared light. The light our eyes are capable of seeing falls between 400 and 700nm's, but infrared light goes far beyond this range. My current main camera, the Canon 1DS MK2, filters out the infrared wavelengths so efficiently that I have had no success at all with my infrared attempts when using it.

I have found a solution, however, and that lies with older digital cameras. it is worth scouring the second-hand marketplace for these. The model that I find gives consistently good results is the Fuji FinePix S2 Pro. This is a great camera and, when used with a good lens such as the Nikon AF-S 17–35mm f2.8, the results can be simply stunning. To get the infrared effect, you have to use a filter that transmits light above 730nm's. I use a Lee gel No 87 filter, which appears completely black. Because of this, very long exposures are usually required - 30 seconds is not uncommon in certain situations.

Left: I took this picture using a digital camera with a No 87 filter on the lens. I had to mount the camera on a tripod and compose the picture before attaching the filter, as it is so dark it is impossible to see through the viewfinder once it is in place.

Opposite: As the filter is so dark, longer exposures than normal are required. This is another reason why a tripod is essential. You can see that it was a long shutter speed by the movement in the clouds and trees.

Above: This picture was taken just before the sun set. You can see that it is late in the day by the length of the shadows the trees are making. The blue sky has gone an inky black. I could have achieved a similar effect with the sky if I had used a red filter, but the trees would have come out far too dark.

Opposite, above: One great aspect of shooting infrared can be the reflections of trees in water. Here the trees, which have reproduced in a brilliant white, have reflected white in the water as well.

Opposite, below: Lighting is a very important factor when shooting infrared. In this shot, you can see that the trees in the background have reacted well in the sunshine and have gone quite white. The trees on the left, however, are in the shade and the foliage, although light, looks dull in comparison.

Abstracts

Besides taking images of instantly recognisable subjects that are correctly exposed, composed and printed, there are many other photographic possibilities if you open up the world of abstracts. Black and white is a great medium for these because of its graphic quality and lack of the distractions that colour can create.

Although some abstracts might be "straight" shots, in other words, without computer manipulation, it is the nature of the subject and the way it has been presented that makes them non-representational. An abstract composition might be something as simple as a reflection in a building or water, or in the reflective side of a building or vehicle. When you try to shoot these kinds of reflected images, the camera's autofocus might have difficulty fixing on the reflection and instead focus on the surface. This could result in the reflection being out of focus. Although this might lend a further degree of abstraction, it might also be too confusing to create a coherent image. To be certain of getting the correct focus, it is better to control this manually.

Another way to create an abstract shot is to photograph it deliberately out of focus and with minimum depth of field. As before, it will be advisable to turn off the autofocus to give you greater control. This method will soften the edges of your shot and, depending on the degree of focus, will slightly blur the image.

Zooming the lens while taking your shot is a popular and effective way of producing abstracts. This is best done with the camera on tripod and a slow shutter speed of around 1/8th second. As soon the shutter button has been depressed, adjust the lens' focal length smoothly throughout its range.

Even if you have taken a straight shot, the possibilities for abstraction are endless once you have downloaded it into the computer, or scanned your transparency or negative. For instance, just by using the Brightness/Contrast control or the Invert tool in Photoshop, a whole raft of experiments are possible. Abstraction can also be achieved with multiple images, as can be seen with the examples on pages (110–113).

Left: Abstract pictures can be created in a variety of ways. Many of these are quite simple. For instance, these soft drink cans had just been delivered in shrink wrap packaging to a store and were left outside. I thought they made a great pattern and took a few shots. After I had downloaded them onto the computer, I inverted the image, which looked even more striking.

Opposite: This was another opportunist shot that I happened upon by chance. The building had a terrace that was criss-crossed by several concrete beams. The sun was high and bright and caused the beams to cast shadows in an almost painterly way. The whole building looks as though it is a canvas that has been painted with stripes in a very ordered manner.

Overleaf: Modern buildings provide countless opportunities for creating unusual and abstract imagery. In this shot, one building has reflected into another and this has created a series of random patterns in the glass panels.

Close-Ups

With a macro lens, you should be able to shoot a small subject life-size and, if you combine this lens with either extension tubes or bellows fitted between the camera body and the lens, the magnification will be even greater. However, they can only be used with cameras that have interchangeable lenses, such as SLR's.

Depending on your camera, extension tubes come in a variety of different lengths and can be mounted together for extreme magnification. The longer the set of tubes is, the closer you can get and therefore the greater the magnification. However, depending on the combination that you use, the distance of the lens to the subject will be fixed. Extension bellows, on the other hand, have the advantage of variable magnification and allow far more precise framing of your subject when going in close.

Although depth of field will be minimal, it still exists, so if you stop the lens right down and use the maximum depth of field possible, you still need to pay attention to the background.

Even at these distances, unsightly details can come into focus and ruin the overall composition. Another mistake is to think that stopping down to the smallest aperture creates the sharpest shots. All lenses have an optimum aperture for the sharpest focus. On a lens with an aperture range of f2.8 to f22, depth of field will be at its greatest when the aperture is set to f22. However, the sharpest shot is one taken when the lens is set to f11, because diffraction – the bending or spreading out of light as it passes through a narrow aperture – reduces the overall image definition and resolving power.

Many cameras, compacts included, come with a built-in macro device. If you are using a digital version, then you will be able to view your subject on the camera's LCD. However, if you are using a compact film camera, then there will be a disparity between what the lens sees and what the viewfinder sees, known as parallax error. You will have to compensate to correct it, otherwise some of your intended shot will not be included in the frame. SLR cameras do not have this problem.

Left: I shot this snail using a 100mm macro lens together with a No 1 and No 2 extension. This enabled me to get to within about 100mm and the snail appears at least twice life size.

Above: Flowers are great subjects for close-up photography. However, they need to be really fresh and in an absolutely pristine condition. The slightest blemish will show up like a sore thumb when shooting this close.

Opposite: For extreme close-ups, care needs to be taken that you or your camera and lens don't cast a shadow over your subject.

Above left and right: I shot these architectural fittings, and the one on pages 54–55, using a combination of lens, but always with a No 1 extension tube. This, together with a large aperture of f2.8, meant that the focus had to be precise as the depth of field was minimal. Shooting like this can add a dynamism to the pictures and create a real sense of perspective.

Retouching

No matter how careful we are with our transparencies or negatives, it is possible that one or two of them might become scratched or damaged. This is why it is so important to keep all your equipment in good working order. Dust or grit on the inside of a camera can scratch a film its entire length, causing every single shot to be damaged. If you are using 35mm film and do not keep the cassette in its container, before and after exposure, then, again, dust could get onto the fabric of the opening and ruin your shots. Spilt liquid and grease on film are other potential problems, along with the ultimate disaster, which is when a negative or transparency gets torn.

It might be the case that your original negative or transparency has been lost and that you only have a print, which has been creased, torn and faded. Not long ago this would have meant re-photographing the print and producing further copies from it. However, you would first have to spend many hours retouching the print by hand, otherwise you would simply end up with a new version of the damaged image. If you wanted more than one print, the re-touched version would have to be photographed again, thereby reducing the quality still further. Nowadays, with the computer, it is possible to scan our prints, negatives or transparencies and retouch them much more easily by using a program such as Photoshop.

Besides restoring original pictures to their former glory, there are many other reasons for retouching photographs. It could be that some areas of the image are over or underexposed, or that an unsightly telegraph pole, pylon or building marred the view, but it was impossible to shoot from a different angle. It can often happen, too, that when you view a shot on the computer or as a print, you spot something, like a signpost, or just irritating foliage, that you hadn't noticed as you took it. These can be touched out with relative ease on the computer. If people comment in a sneering way that this is manipulation, then point out that landscape painters have taken this approach for centuries without being criticised for it.

Retouching an old print

Opposite far left: As can be seen this picture has deteriorated over time and is now in quite a distressed state. It is fraying at the edges, has been creased and has also become discoloured. I scanned the original print on a desktop scanner and, although it is heavily damaged, it has retained enough detail, even though the scanning process has softened it.

Step 1: Using the Hue/Saturation mode I desaturated the picture to remove all colour.

Step 2: Using Levels, I set the black and white points. The histogram tells me where the tones in the image are located.

Step 3: I then used Curves to add contrast to the image. Although this has a similar effect to Levels, it allows greater control.

Step 4: Using the Clone tool, I selected areas of texture and painted over the spots and cracks. This is a much more controllable tool than the Healing Brush.

Step 5: For larger areas of damage, I used the Patch tool by drawing a selection around the area that needed patching and then moving to an area of undamaged texture. The computer then blends the new area into the old area.

Opposite, right: The restored and finished photograph.

1

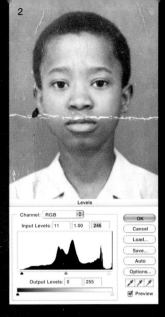

2

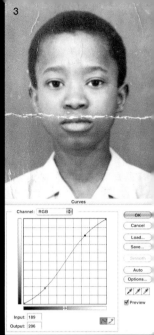

3

4

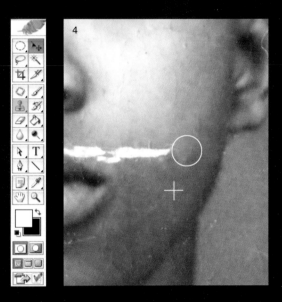

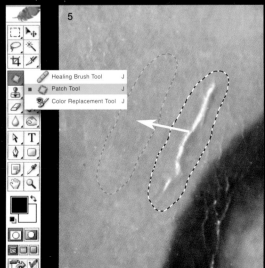

5

Healing Brush Tool J
Patch Tool J
Color Replacement Tool J

Enhancing a photograph

The original shows an unevenly exposed shot with heavy shadow detail in the trees on the right and on the hill to the left.

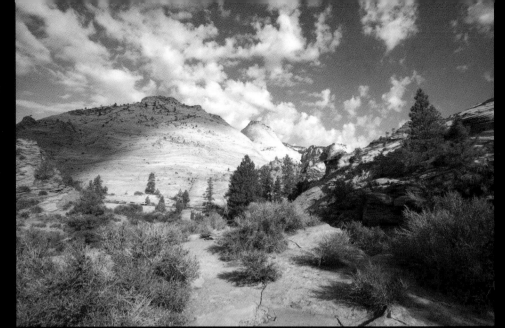

Step 1: I first made a selection and feathered the edges. Then, using Curves, I lightened the shadow area to what I thought was a more acceptable level.

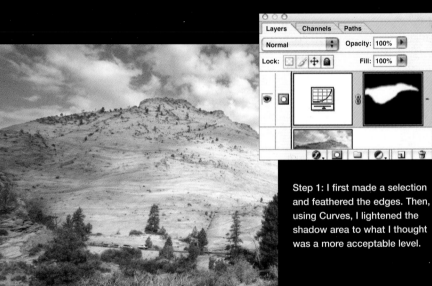

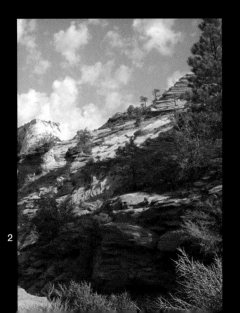

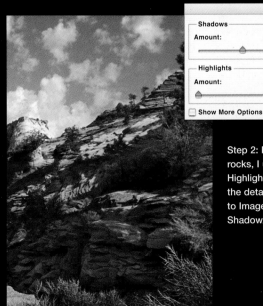

Step 2: In the shadow area of the rocks, I used the Shadow/Highlight command to bring out the detail. This is found by going to Image > Adjustments > Shadow/Highlight.

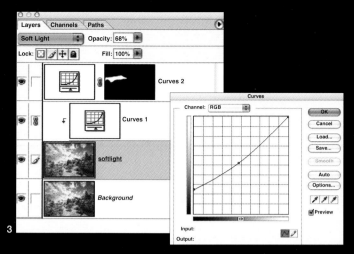

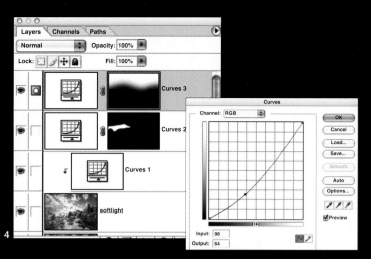

Step 3: To add contrast, I then duplicated the picture layer and turned the Blending mode into softlight. Using Curves in the new layer, raise the dark point of the Curve.

Step 4: I adjusted the sky by using the Lasso tool and feathered the edges, in much the same way that I did in step 1. I then used Curves to adjust the contrast until it was to my liking.

Below: The finished photograph, now showing a much better range of tones.

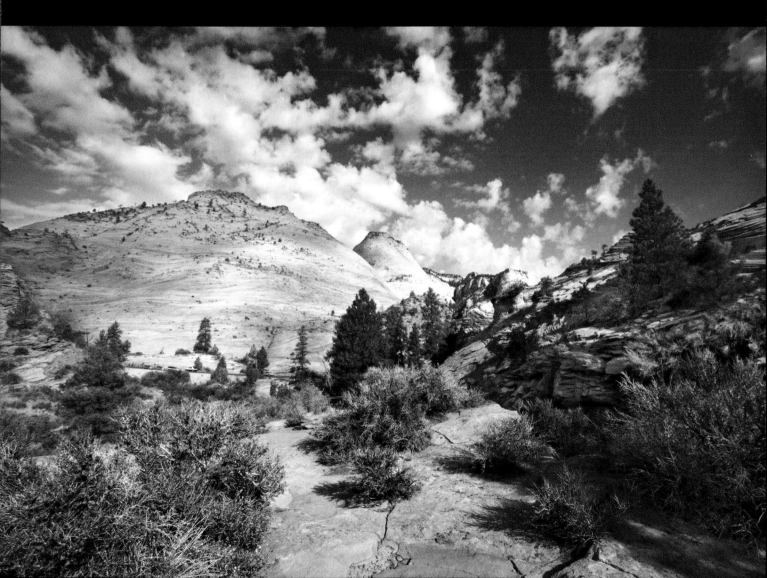

Toning

As photographic computer technology progresses at an ever increasing pace, it is now possible for computers, combined with the latest, sophisticated inkjet printers, to perform as a digital darkroom, capable of producing prints that surpass anything that can be produced in a traditional wet darkroom.

Of course, there are still plenty of photographers around who argue that computers do not require the same level of skill and are merely a means of manipulation. Whenever I come across this point of view, I reply that photography has always involved a degree of manipulation, ever since the first sepia toned print was created many decades ago. Other art forms, such as painting, are no different. As for needing the minimum of skill, high-end digital printing requires skills far in excess of traditional darkroom techniques. The latter have always had their limitations, as there are a finite number of processes that involve one or more chemicals (which are harmful to the environment) reacting with the print.

Digital image processing gives you far more scope and is only limited by your imagination. Another great benefit is that you can preview each image to ensure that it is exactly how you want it before making the final print. Many of the images produced on computers mimic some established darkroom techniques, probably because this is what we are used to seeing. But as more people discover and experiment with digital imaging, new standards are bound to evolve and become a natural extension of the photographer's repertoire.

If you are going to take many photographs in black and white, or convert your colour shots to it, digital toning is an invaluable technique to learn. Whatever the subjects you prefer to shoot, many images will greatly benefit from the addition of a tone, even if it is just a subtle hint of it. Whereas a toned print will have an overall effect, either as a duotone, tritone or quadtone, there are also methods to selectively tone individual areas of the image, giving a similar impression to traditional hand-colouring.

Toning

It is not necessary to start with a black and white picture when producing monochrome images on a computer. Although this is a perfectly acceptable shot, I felt a lot more could be achieved if it were converted to black and white.

Above: I used Photoshop Curves to adjust the tones and colour. The curve is plotted on a grid; by default it is a straight line. The bottom left point represents the brightest part of the image and is known as the D-min or the point of minimum density. The top right point is the darkest part of the image, or D-max. Any point between these can be clicked on and dragged with the mouse. The image will become brighter if pulled down and darker if pushed up. By default, the curve dialogue box opens with all the colours (RGB) selected. This means that you alter all the colours together and only the brightness is adjusted.

Step 1: The image has been converted to black and white but looks very flat because it lacks contrast. You can increase the contrast by clicking and dragging the curve tool until the desired effect has been achieved.

2

3

Step 2: To introduce a blue tone, I used the Hue/Saturation control. The hue slider selects the colour (or chroma) and the saturation controls the intensity of the colour. For a toned print it is best to keep the saturation low.

Step 3: I tried a similar technique to produce a sepia toned effect. You can see the different value that this required in the Hue box.

4

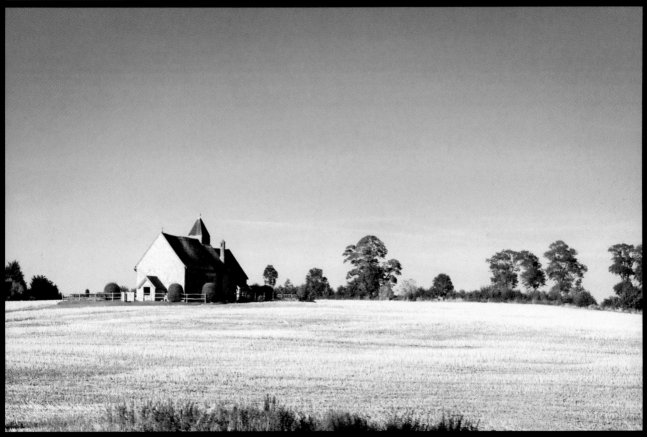

Step 4: In Curves, I manipulated the RGB Channel and then progressively the Red, Green and Blue Channels to arrive at a lith effect. I used this as my final image.

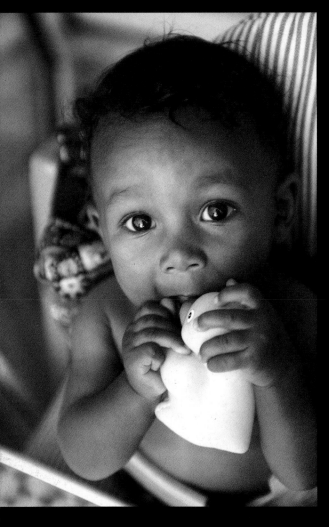

Selective toning

Sometimes I like to add selective colour to a monochrome print and just highlight one part of the image.

Step 1: I created a new layer and chose from the Colorpicker by clicking on the two colour squares that are located at the bottom of the toolbar. I chose a soft brush from the toolbar and roughly painted over the area I wanted toned.

Step 2: I turned on the newly painted layer. This blended with the layer below using only the colour information.

Step 3: I then used the Eraser from the toolbar on the colour layer to tidy up colour that had been spilt outside my selected area. The finished shot remains monochrome except for the child's yellow duck.

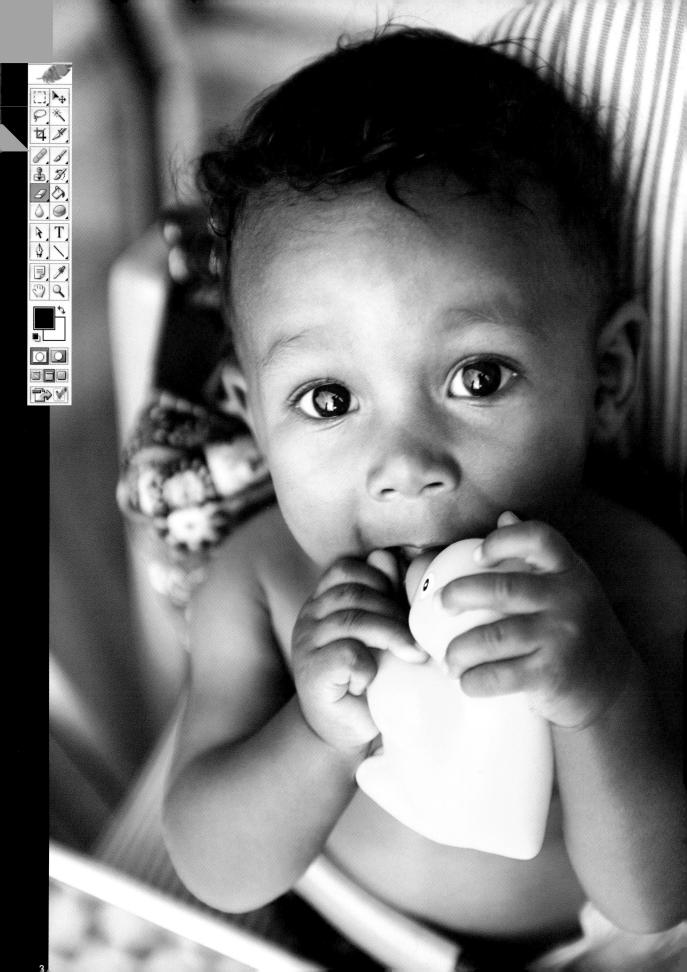

High Contrast

High contrast photographs are where the tones are taken from the extremes of the spectrum, with few, if any, mid-tones. They are not to be confused with high-key photographs, where the range of tones in the finished shot is taken from the light end of the spectrum.

Creating high-impact images by stripping the original down to basics, without any tonal range whatsoever, is a common printing technique, which is sometimes referred to as posterization. It is frequently used in the advertising industry, where it is recognised as an effective way of catching people's attention. The use of image manipulation programs has made it another very accessible tool at the photographer's disposal.

High-contrast pictures force the eye to concentrate on specific areas of your shot and so can make very strong, graphic compositions. When photographed, or reproduced, in black and white, all tones from the middle area of the greyscale are eliminated. The subject matter for this type of photograph needs careful thought. Look for strong shapes and outlines that will make effective silhouettes against a pale sky. Too much detail in the composition may result in it looking muddled and reduce the impact that you are trying to achieve.

As with so many photographic techniques, inspiration can be drawn from paintings and the work of graphic artists, which can be good references for styles that you might want to adopt. Andy Warhol, for example, used the high contrast technique extensively, especially in his silkscreen prints.

While high contrast effects have traditionally been produced in the wet darkroom using high contrast papers and developers, there is just as much, if not more, scope for creating this type of imagery on the computer. A program such as Photoshop enables you to create high-contrast images and then reproduce them quite quickly. The easiest way to do this is to go to Image > Adjustments > Brightness/Contrast. Here you will be able to use the contrast control and, by sliding it to the right, all the tone will be gradually stripped away from the image and you can stop when you have reached the desired effect.

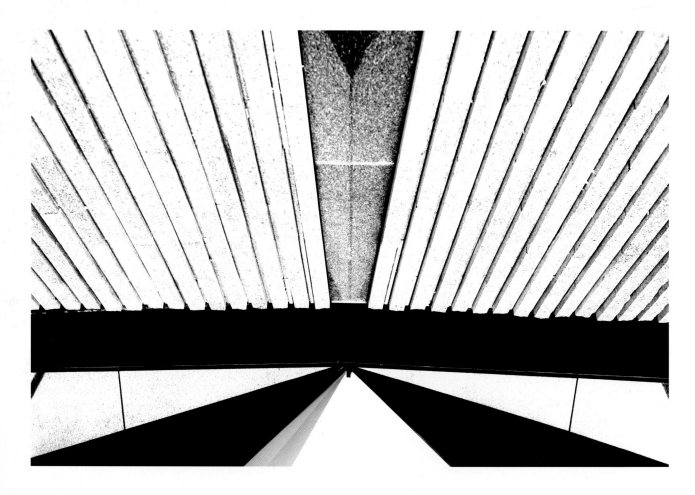

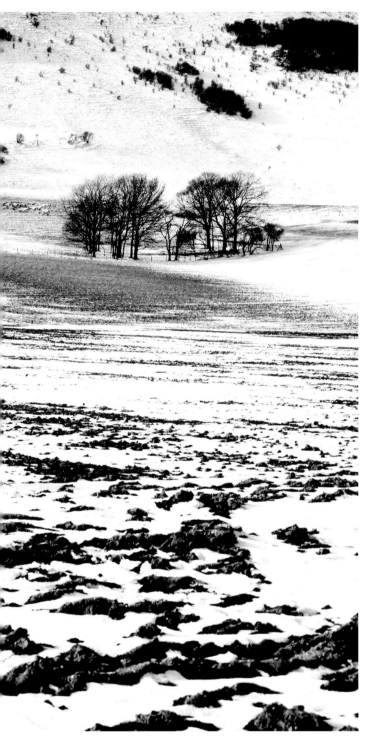

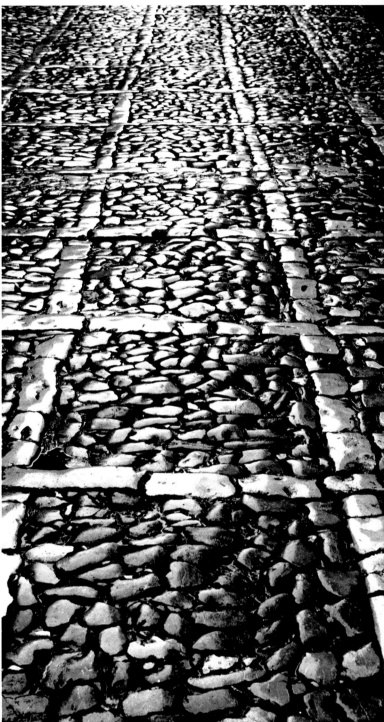

Opposite: The detail of this building has provided the perfect ingredients for a high contrast image. I used the Brightness/ Contrast control to adjust the contrast to the intensity that I wanted.

Above left: This landscape was covered in a light fall of snow and was a high contrast image to begin with. I made few adjustments other than to clean up the whites and intensify the blacks.

Above right: This cobbled path was glistening after a rain shower and I knew that it would make a good high contrast shot. Using the Brightness/ Contrast control I reduced it to purely black and white.

Overleaf: The engine of this Harley Davidson motorcycle made a great high contrast image. The metalwork, chrome and leather worked well, as none of them had any mid-tones to speak of. The shot has ended up as a highly graphic image of a beautifully engineered bike.

Glossary

Alpha Channel
Extra 8 bit greyscale channel in an image, used for creating masks to isolate part of the image.

Analogue
Continuously variable.

Aperture
A variable opening in the lens determining how much light can pass through the lens on to the film.

Aperture Priority
A camera metering mode that allows you to select the aperture, while the camera automatically selects the shutter speed.

Apo Lens
Apochromatic. Reduces flare and gives greater accuracy in colour rendition.

APS
Advanced Photo System.

ASA
American Standards Association; a series of numbers that denotes the speed of the film. Now superseded by the ISO number, which is identical.

Anti-aliasing
Smoothing the edges of selection or paint tools in digital imaging applications.

Auto-focus
Lenses that focus on the chosen subject automatically.

B Setting
Setting on the camera's shutter speed dial that will allow the shutter to remain open for as long as the shutter release is depressed.

Back Light
Light that is behind your subject and falling on to the front of the camera.

Barn Doors
Moveable pieces of metal that can be attached to the front of a studio light to flag unwanted light.

Between The Lens Shutter
A shutter built into the lens to allow flash synchronization at all shutter speeds.

Bit
A binary digit, either 1 or 0.

Blooming
Halos or streaks visible around bright reflections or light sources in digital pictures.

BMP
File format for bitmapped files used in Windows.

Boom
An attachment for a studio light that allows the light to be suspended at a variable distance from the studio stand.

Bracketing
Method of exposing one or more frames either side of the predicted exposure and at slightly different exposures.

Buffer RAM
Fast memory chip on a digital camera.

Byte
Computer file size measurement.
1024 bits=1 byte
1024 bytes=1 kilobyte
1024 kilobytes=1 megabyte
1024 megabytes=1 gigabyte

C41
Process primarily for developing colour negative film.

Cable Release
An attachment that allows for the smooth operation of the camera's shutter.

Calibration
Means of adjusting screen, scanner, etc, for accurate colour output.

Cassette
A light-tight container that 35mm film comes in.

CC Filter
Colour Correction filter.

CCD
Charged Coupled Device. The light sensor found in most digital cameras.

CDR
Recordable CD.

CD-ROM
Non-writable digital storage compact disk used to provide software.

CDS
Cadmium sulphide cell used in electronic exposure meters.

Centre-weighted
TTL metering system which is biased towards the centre of the frame.

Cloning
Making exact digital copies of all or part of an image.

Clip Test
Method of cutting off a piece of exposed film and having it processed to judge what the development time should be of the remainder.

CMYK
Cyan, magenta, yellow and black colour printing method used in inkjet printers.

Colour Bit Depth
Number of bits used to represent each pixel in an image.

Colour Negative Film
Colour film which produces a negative from which positive prints can be made.

Colour Reversal Film
Colour film which produces positive images called transparencies or slides

Colour Temperature
A scale for measuring the colour temperature of light in degrees Kelvin.

Compact Flash Card
Removable storage media used in digital cameras.

Compression
Various methods used to reduce file size. Often achieved by removing colour data (see JPEG).

Contact Sheet
A positive printed sheet of a whole processed film so that selected negatives can be chosen for enlargements.

Contrast
Range of tones in an image.

CPU
Central Processing Unit. This performs all the instructions and calculations needed for a computer to work.

Cross-processing
Method of processing colour film in different developers, ie colour reversal film in C41 and colour negative in E6.

Cyan
Blue-green light whose complementary colour is red.

Dark Slide
A holder for sheet film used in large format cameras.

Data
Information used in computing.

Daylight Balanced Film
Colour film that is balanced for use in daylight sources at 5400 degrees Kelvin.

Dedicated Flash
Method by which the camera assesses the amount of light required and adjusts flash output accordingly.

Default
The standard setting for a software tool or command which is used by a computer if settings are not changed by the user.

Depth of Field
The distance in front of the point of focus and the distance beyond that is acceptably sharp.

Dialog Box
Window in a computer application where the user can change settings.

Diaphragm
Adjustable blades in the lens determining the aperture size.

Diffuser
Material such as tracing paper placed over the light source to soften the light.

Digital Zoom
Digital camera feature that enlarges central part of the image at the expense of quality.

DIN
Deutsche Industrie Norm. German method of numbering film speed, now superseded by ISO number.

Download
Transfer of information from one piece of computer equipment to another.

DPI
Dots Per Inch. Describes resolution of printed image (see PPI).

DPOF
Digital Print Order Format.

Driver
Software that operates an external device or peripheral device.

DX
Code marking on 35mm film cassettes that tells the camera the film speed, etc.

E6
Process for developing colour reversal film.

Emulsion
Light sensitive side of film.

EV
Exposure Value.

EVF
Electronic View Finder found in top quality digital cameras.

Exposure Meter
Instrument that measures the amount of light falling on the subject.

Extension Bellows
Attachment that enables the lens to focus at a closer distance than normal.

Extension Tubes
Attachments that fit between the camera and the lens that allow close-up photography.

F Numbers
Also known as stops. They refer to the aperture setting of the lens.

Feathered Edge
Soft edge to a mask or selection that allows seamless montage effects.

File Format
Method of storing information in a computer file such as JPEG, TIFF, etc.

Film Speed
See ISO.

Filter
A device fitted over or behind the camera lens to correct or enhance the final photograph. Also photo-editing software function that alters the appearance of an image being worked on.

Filter Factor
The amount of exposure increase required to compensate for a particular filter.

Firewire™
High speed data transfer device up to 800 mbps (mega bits per second), also known as IEEE 1394.

Fisheye Lens
A lens that has an angle of view of 180 degrees.

Fixed Focus
A lens whose focusing cannot be adjusted.

Flag
A piece of material used to stop light spill.

Flare
Effect of light entering the lens and ruining the photograph.

Flash Memory
Fast memory chip that retains all its data, even when the power supply is switched off.

Focal Plane Shutter
Shutter system that uses blinds close to the focal plane.

Fresnal Lens
Condenser lens which aids focusing.

Fringe
Unwanted border of extra pixels around a selection caused by the lack of a hard edge.

Gel
Coloured material that can be placed over lights either for an effect or to colour correct or balance.

GIF
Graphic file format for the exchange of image files.

Gobo
Used in a spotlight to create different patterns of light.

Grain
Exposed and developed silver halides that form grains of black metallic silver.

Greyscale
Image that comprises 256 shades of grey.

Hard Drive
Computer's internal permanent storage system.

High-Key
Photographs where most of the tones are taken from the light end of the scale.

Histogram
Diagram in which columns represent frequencies of various ranges of values of a quantity.

HMI
Continuous flicker-free light source balanced to daylight.

Hot Shoe
Device usually mounted on the top of the camera for attaching accessories such as flash.

Incident Light Reading
Method of reading the exposure required by measuring the light falling on the subject.

Internal Storage
Built-in memory found on some digital cameras.

Interpolation
Increasing the number of pixels in an image.

Invercone
Attachment placed over the exposure meter for taking incident light readings.

ISO
International Standards Organization. Rating used for film speed.

Jaggies
Images where individual pixels are visible due to low resolution.

JPEG
A file format for storing digital photographs where the original image is compressed to a fraction of its original size.

Kelvin
Unit of measurement of colour temperature.

Latitude
Usable film tolerance that is greater with negative film than reversal film.

LCD
Liquid Crystal Display screen.

Light Box
A light with a diffused screen used for viewing colour transparencies.

Lossless
File compression, such as LZW used in TIFF files, that involves no loss of data or quality in an image.

Lossy
File compression, such as JPEG, that involves some loss of data and thus some quality in an image.

Low-Key
Photographs where most of the tones are taken from the dark end of the scale.

Macro Lens
A lens that enables you to take close-up photographs.

Magenta
Complementary colour to green, formed by a mixture of red and blue light.

Marquee
An outline of dots created by an image-editing program to show an area selected for manipulation or work.

Mask
An 8-bit overlay that isolates part of an image prior to processing; the isolated area is protected from change. The areas outside the mask are called the selection.

Megapixel
1,000,000 pixels.

Mirror Lock
A device available on some SLR cameras which allows you to lock the mirror in the up position before taking your shot in order to minimize vibration.

Moiré
An interference pattern similar to the clouded appearance of watered silk.

Monobloc
Flash unit with the power pack built into the head.

Montage
Image formed from a number of different photographs.

Morphing
Special effect where one image changes into another.

Network
Group of computers linked by cable or wireless system so they can share files. The most common form is ethernet. The web is a huge network.

Neutral Density
A filter that can be placed over the lens or light source to reduce the required exposure.

Noise
In digital photography, an effect that occurs in low light that looks like grain.

Optical Resolution
In scanners, the maximum resolution possible without resorting to interpolation.

Pan Tilt Head
Accessory placed on the top of a tripod that allows smooth camera movements in a variety of directions.

Panning
Method of moving the camera in line with a fast moving subject to create the feeling of speed.

Parallax Correction
Movement necessary to eliminate the difference between what the viewfinder sees and what the camera lens sees.

PC Card
Removable cards that have been superseded by flash cards.

PC Lens
Perspective control or shift lens.

Peripherals
Items connected to a computer, such as scanners.

Photoshop
Industry standard image manipulation package.

Pixel
The element that a digitized image is made up from.

Plug-in
Software that adds extra features to image-editing programs.

Polarizing Filter
A filter that darkens blue skies and cuts out unwanted reflections.

Power-up time
Measure of a digital camera's speed of operation from being switched on to being ready to take a photograph.

Predictive Focus
Method of auto-focus that tracks a chosen subject, keeping it continuously sharp.

Prop
An item included in a photograph that enhances the final composition.

Pulling
Decreasing the development of the film.

Pushing
Rating the film at a higher ISO and then increasing the development time.

Quick Mask
Photoshop mode that allows a mask to be viewed as a colour overlay on top of an image.

RAM
Random Access Memory.

Rangefinder Camera
A camera that uses a system which allows sharp focusing of a subject by aligning two images in the camera's viewfinder.

Reciprocity Failure
The condition where, at slow shutter speeds, the given ISO does not relate to the increase in shutter speed.

Refresh Rate
How many times per second the display on an LCD preview monitor is updated.

Resizing
Altering the resolution or physical size of an image without changing the number of pixels.

Resolution
The measure of the amount of pixels in an image.

RGB
Red, Green and Blue, which digital cameras use to represent the colour spectrum.

Ring Flash
A flash unit where the tube fits around the camera lens, giving almost shadowless lighting.

ROM
Read Only Memory.

Saturation
The amount of grey in a colour; the more grey present, the lower the resolution.

Selection
In image-editing, an area of a picture isolated before an effect is applied; selections are areas left uncovered by a mask.

Shift and Tilt Lens
Lens that allows you to shift its axis to control perspective and tilt to control the plane of sharp focus.

Shutter
Means of controlling the amount of time that light is allowed to pass through the lens onto the film.

Shutter Lag
The delay between pressing the shutter release and the picture being taken.

Shutter Priority
Metering system in the camera that allows the photographer to set the shutter speed while the camera sets the aperture automatically.

Slave Unit
Device for synchronizing one flash unit to another.

SLR
Single Lens Reflex camera.

Smart Media
Type of digital camera removable media used by some camera manufacturers.

Snoot
Lighting attachment that enables a beam of light to be concentrated in a small circle.

Spill
Lighting attachment for controlling the spread of light.

Spot Meter
Method of exposure meter reading over a very small area.

Step Wedge
A greyscale that ranges from white to black with various shades of grey inbetween.

Stop
Aperture setting on a lens.

T Setting
Used for long time exposures to save draining the camera's battery.

Tele Converter
Device that fits between the camera and lens that extends the lens' focal length.

Thumbnail
A small, low-resolution version of an image, used like a contact sheet for quick identification.

TIFF
Tagged Inventory File Format. The standard way to store digital images.

TLR
Twin Lens Reflex camera.

TTL
Through The Lens exposure metering system.

Tungsten Balanced Film
Film balanced for tungsten light to give correct colour rendition.

TWAIN
Industry standard for image acquisition devices.

Unsharp masking
Software feature that sharpens areas of high contrast in a digital image while having little effect on areas of solid colour.

USB
Universal Serial Bus. Industry standard connector for attaching peripherals with date transfer rates up to 450 mbps (mega bits per second).

Vignetting
A darkening of the corners of the frame if a device such as a lens hood or filter is used that is too small for the angle of view of the lens.

White Balance
Method used in digital cameras for accurately recording the correct colours in different light sources.

ZIP
An external storage device which accepts cartridges between 100 and 750 megabytes.

Zoom Lens
Lens whose focal length is variable.

Index

Acknowledgements

John Freeman and Anova Books would like to thank Calumet Photographic UK and Fuji UK for their assistance in the production of this book.

This book would not have been possible without the help and assistance of many people. In particular I would like to thank Alex Dow, my digital guru, without whom there would be no book! His dedication to the project and his technical expertise, cannot be spoken of highly enough. I would also like to thank my editor, Chris Stone, who in spite of all the upheavals, managed to get me to produce the book on time. Well almost! To Grade Design for the original design concept and Philip Clucas for the design; Robert Brandt for the illustrations. The staff at The Oustau Baumaniere; Bettina Graham; Other people who provided much needed assistance were, Janine Bastos and family; Melanie Boorman; Kofi Browne; Ciara Catalano; Sam Coleman; Bill Cooke; Daz Crawford; Octavia, Ronnie and Nancy Hedley-Dent; Suki Drane; Allegra Freeman; Katie Freeman; Luke Freeman; Vanessa Freeman; Stephanie Grant; Griff; Monica Harris; Alfred Kouakou; Katie Lawrie; Nathan Long; Paul Malcahy; Nnaceesay Marenah; James Meakin; Helen Moody; Holly Newberry; Teddy North; Patrick O'Reilly; Ade Osoba; Chris Pailthorpe; Tiphaine Popesco; Yolisa Segone; Pavel Straka; Danialle Tweebeeke; Patrick Wiseman; and if I have forgotten anyone please accept my apologies.